Art in
Felt & Stitch

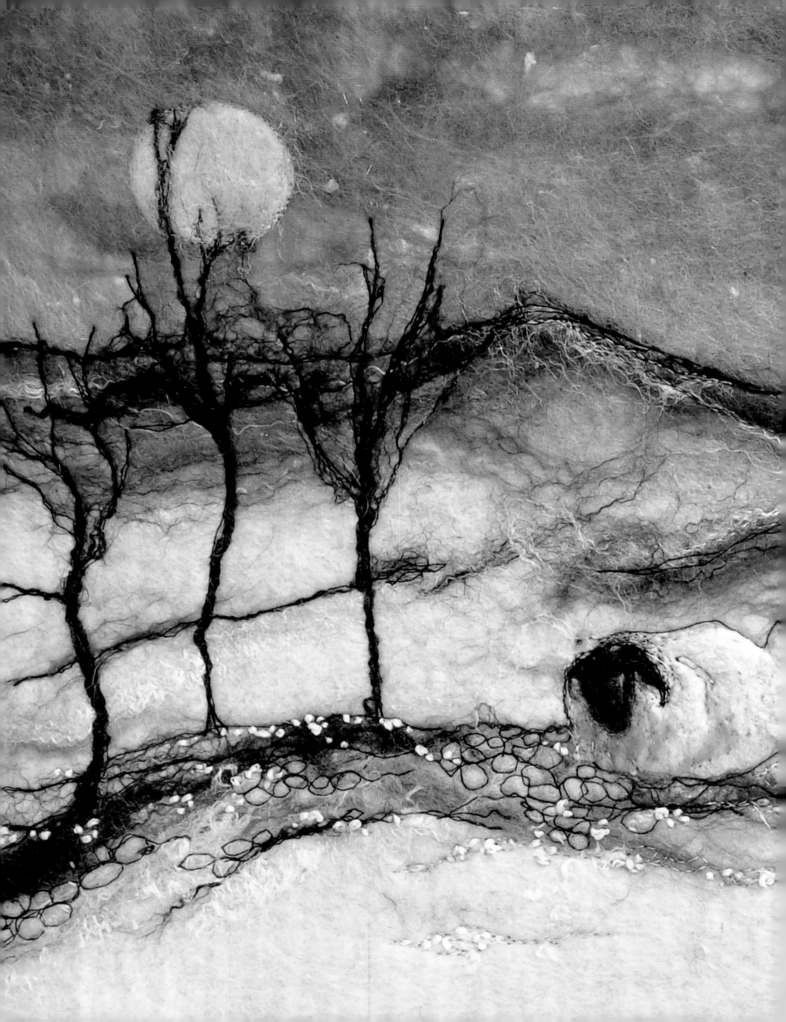

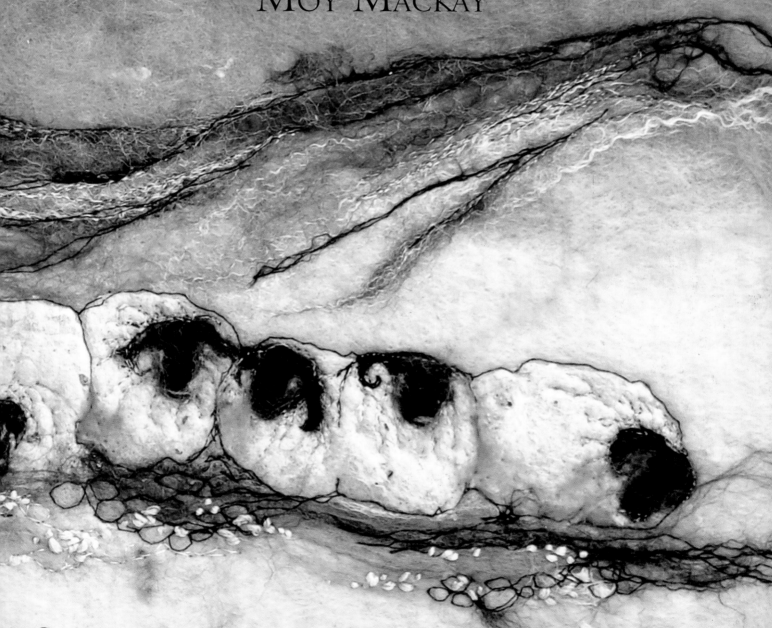

Art in
Felt & Stitch

MOY MACKAY

CREATING BEAUTIFUL WORKS OF ART USING FLEECE, FIBRES AND THREADS

First published in Great Britain 2012

Search Press Limited
Wellwood, North Farm Road,
Tunbridge Wells, Kent TN2 3DR

Reprinted 2012, 2013

Text copyright © Moy Mackay 2012

Photographs by Debbie Patterson (pp 2–3, 7, 25, 76, 95, 112 and 114) and Paul Bricknell (pp 5, 8–9, 12–20, 28–51, 60–75, 82–91, 93, 96–97, 99–109, 111 and 116–128) copyright © Search Press Ltd 2012

Additional photographs by Kenneth Martin Photography (pp 10–11) and Mike Day (back cover flap). All remaining photographs were taken by the author.

Design © Search Press Ltd 2012

ISBN: 978-1-84448-563-5

The Publishers and author can accept no responsibility for any consequences arising from the information, advice or instructions given in this publication.

Readers are permitted to reproduce any of the items/patterns in this book for their personal use, or for the purposes of selling for charity, free of charge and without the prior permission of the Publishers. Any use of the items/patterns for commercial purposes is not permitted without the prior permission of the Publishers.

Suppliers
For details of suppliers, please visit the Search Press website: www.searchpress.com.

Publisher's note
All the step-by-step photographs in this book feature the author, Moy Mackay, demonstrating how to create pictures with felt. No models have been used.

Printed in Malaysia

Dedication

This book is dedicated to my mother, Mary Mackay.

Acknowledgments

I would like to thank my mother for nurturing my love of arts and crafts from an early age. My uncle, John Prentice, was my life-long painting guru and my aunt, the late Helen Crummy, was truly inspirational. Their wise words and creative support encourages me to this day.

Thank you also to Katie from Search Press for all her help and support throughout this rich and rewarding process. Your many lifts and biscuits will not be forgotten! I am also grateful to Deborah Murray for aiding me with her wise words.

Last but certainly not least I would like to thank my partner Johnny and our two sons Eirinn and Saul, who have patiently shared their home with an abundance of brightly coloured fleece for many years now. My apologies for sending you off to school and work with bits of fluff sticking to you in strange places!

Page 1
Highland Reds
100 x 100cm (39½ x 39½in)

Here I wanted to capture the richness of the blood-red sky against the still, clear waters. By using firey reds, russets and earthy browns alongside cool greens, blues and lemon the contrast remains as striking as I had hoped for.

Pages 2–3
Winter Cheviots
42 x 32cm (16½ x 12½in)

To encapture the freezing, glistening winter's day I chose a palette of cold colours, black and white. Angelina fibres added sparkle to the sky. Machine-stitched black lines gave structure and definition to the sheep and trees.

Page 5
Detail from Anemones, page 109.

CONTENTS

Introduction 6

Materials and equipment 10

Inspiration 20

Colour 22

Texture 26

Composition 28

Techniques 30

Landscapes 52

Birds 76

Flowers 92

Still life 110

Index 128

INTRODUCTION

Since I was a very small child I have loved painting, drawing and 'making things'. I was fortunate to be encouraged in this by both my creative mother and her brother – my uncle, a painter, who nurtured my early efforts with smiles and invitations to observe him at work. The pleasure he took in his art and the process of creating it sent a clear and positive message to me, which I hope is communicated in the pages ahead.

I was first introduced to the basics of felt making at art school. It was a somewhat underwhelming experience, far removed from the breadth of possibility I hope to demonstrate in this book. As one of the earliest fabrics known to man, there is significant appeal in moulding what is an ancient craft into a contemporary work of art, particularly as the materials are so similar to those originally used in early times. Felting was achieved before human beings could weave, spin or knit, and I am always surprised that it is not more widely promoted as an art form. I try to create work that utilises colour and subjects in an uplifting, inspiring way. The effects, especially the healing effect that colours can have on a situation or mood, intrigues and excites me.

Before I discovered felting, I painted from an early age. My 'lightbulb moment' came when I decided to try combining the two. I wanted to see if I could channel my love of painting in a different way while still achieving my goal of reflecting the beauty of the landscape and all the subjects which inspired me. My 'felt paintings', as I call them, are just that, a way of placing the strokes of coloured fibres as one would place brushstrokes. The results are strikingly rich in colour and texture, and as my passion is for colour, there is a great deal of satisfaction to be had from working with this medium in this way.

Orange Blossom Special Songbird

38 x 38cm (15 x 15in)

By contrasting vibrant blues with bright oranges and yellows, this piece has a strikingly bold feel. Large stitch marks were added to create a more decorative, design-like quality.

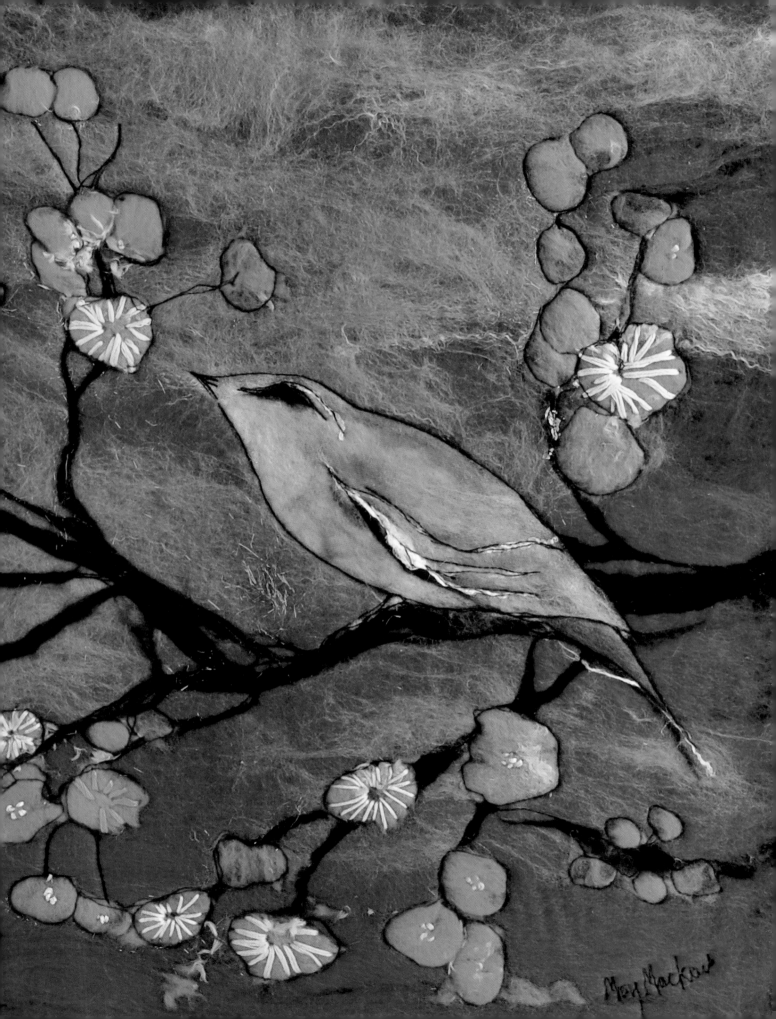

Many people are familiar with the basics of felt making, even if it is just the result of putting a wool sweater into a hot wash. The soap and hot water and the friction of the machine matt the fibres together making the wool shrink and become more dense. The same happens when you create a felt painting. By adding soap and hot water to your painting in a prescribed way, the fibres will matt together. Fine detail can then be added by using a combination of hand and freehand machine embroidery. This produces a versatile artwork that can then be used in a number of ways, from a sculpted artwork to a framed wall piece.

Although this book will benefit those with prior experience of felting, I would like to inspire those who may hesitate to try it, largely because of the emphasis I place on using other media as a form of preparation – drawing, painting, even photography.

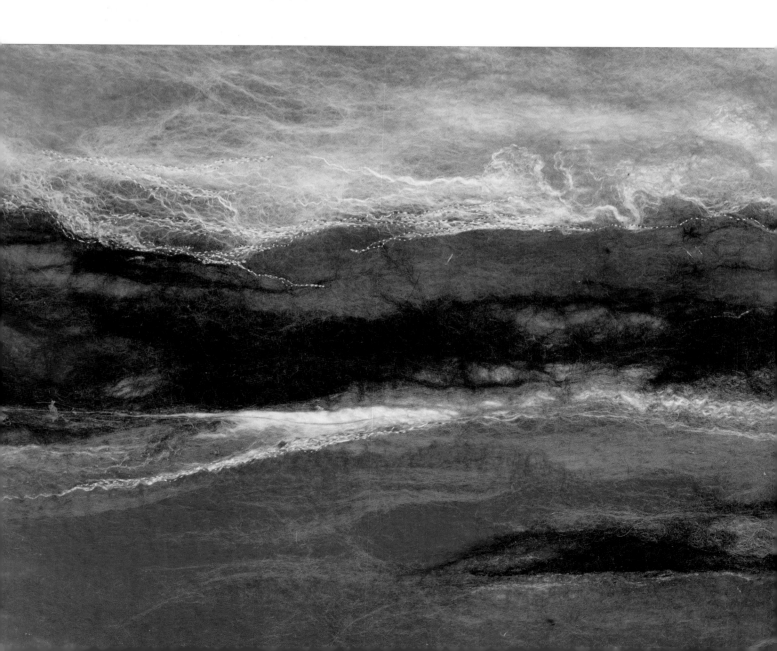

I have led many workshops over the years and find that anyone, regardless of their skill level, can create something special through felt painting. Whilst children tend to embrace the medium, with the use of colour being a big attraction, adults can find it quite daunting. Many have had bad experiences with art at school and do not trust that they are capable of creating works of art, but all successfully do. It is a very satisfying artform both to watch and experience and has been described as a very calming and therapeutic process.

To that end I'd like to encourage readers to be brave and push their boundaries in the pictures they attempt to create in felt, and I hope that this book will inspire and guide you.

Windswept April on the Isle of Skye

25 x 10cm (9¾ x 4in)

Shades of pinks and purples were mixed with all the colours used in this piece to capture the stunning early spring light that bathed the island.

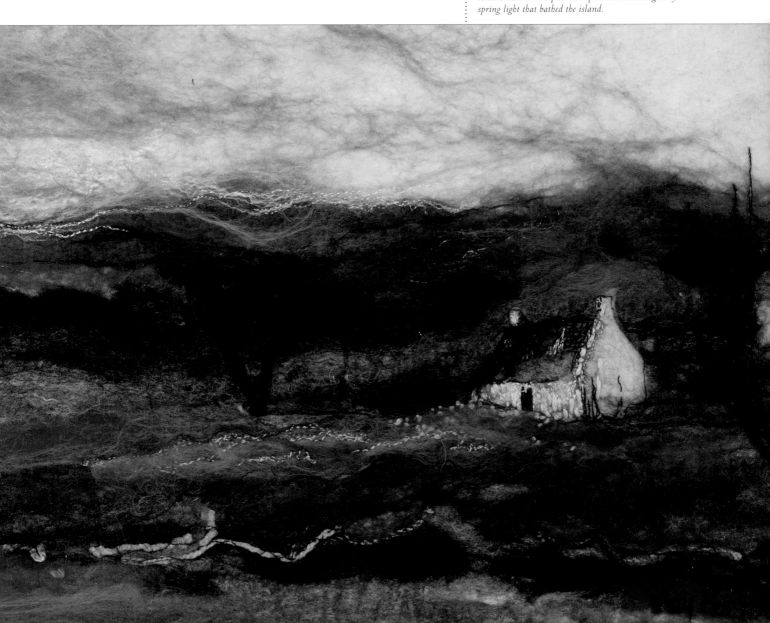

MATERIALS AND EQUIPMENT

Creating felt paintings does not require vast amounts of equipment or materials. A table with a water source in easy reach and a washable floor provide the best environment in which to work. Felting outdoors is ideal on calm, dry days. Sadly, Scottish weather rarely offers these conditions! My worktop consists of three plastic trestle-type tables. Excess water is collected by a drainage pipe placed carefully in the gaps between the tables, which collects the water and directs it to a plastic bucket. This is very effective and cost-efficient. On top of the tables I place old bamboo screens. These can be recycled from old window blinds. Sheets of bubblewrap can work just as well.

It is essential to have a good stock of dyed merino tops. Suppliers worldwide have fantastic colour ranges available to inspire and delight you. Think of this as your palette and you will get an idea of suitable colours to work with. A large amount of white is good to have as it tends to cost less and is an ideal base for your felt paintings; save the dyed merino for use on top. Add a piece of plastic sacking, muslin or bubblewrap, some soap and hot water and all you need is some elbow grease and a bit of imagination. A satisfying side effect of felting is that it can significantly tone your upper arms too!

One of the walls in my studio is my giant merino palette that is a constant source of inspiration both for myself and fellow artists.

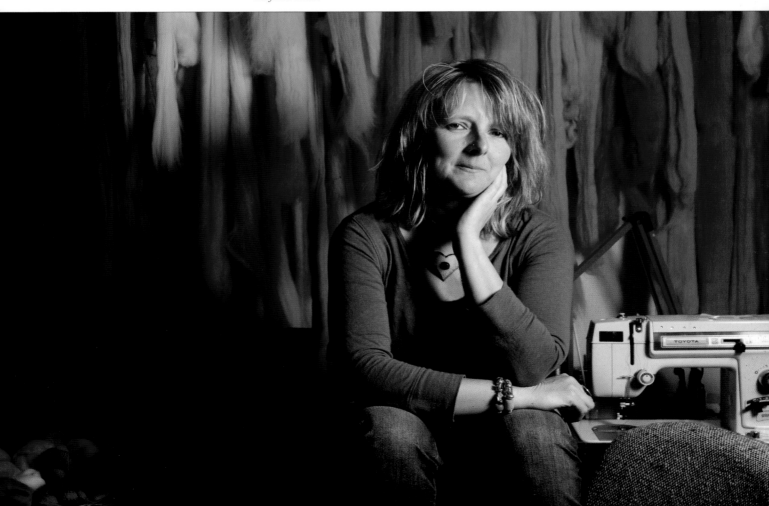

Undyed fleece has a soft, creamy colour that works well as a base for my pictures.

FLEECE

The term 'fleece' usually refers to wool in its raw state, straight from the sheep, before it has been washed, treated and dyed. When living on a sheep farm, I would often send my children out to gather stray sheep's fleece, usually that of Black-faced Cheviots, from the surrounding fields or fences. The wool had to be washed first and hung out to dry. It could, in that raw state, be used to create a felt painting, usually a snow scene unless some coloured fleece was added!

All kinds of sheep's wool can be used, and I have had many commissions from local farmers to create pieces derived from their own sheep's wool. I have worked with wool from Jacob, Hebridean, Lincoln Long Wool and Wensleydale sheep, all of which have very different and interesting coats. The Lincoln and Wensleydale both have long, curly coats that worked wonderfully and gave a stunning curly effect when combined with the merino.

In this book I have used the term 'fleece' loosely to describe the wool fibres I use to make my pictures. These wool fibres are in fact 'wool tops', which are discussed on the facing page.

Rainbow fleece

Rainbow fleece is a combination of dyed merino wool tops and extra bleached tussah silk that creates a rainbow blend with a silky sheen. It can be bought in a variety of colours and can be a very effective yet simple way of achieving interesting finishes that gives a more three-dimensional quality to your work.

I buy these rainbow mixes ready-made but it is possible, and generally more interesting, to try making your own mixes before embarking on a project. This can be done by choosing a variety of similar coloured fibres in equal lengths, including wool and threads if desired. Group them, then gently roll or even card them together. I recommend tying them with an elastic band at the top to keep them in check. They can then hang alongside your merino lengths to be used for future projects.

Rainbow fleece.

WOOL TOPS

Wool tops are a semi-processed product of raw wool. The process requires that the wool be scoured (washed), then combed and sorted. The longer fibres resulting from the process are called tops, and all lie in the same direction, making them ideal for felting. They are available in various lengths and are usually 5–8cm (2–3in) wide.

I was initally attracted to using merino as my substitute painting medium because of the fantastically vibrant range of colours readily available. Some people will choose to create their own colours, often using plant dyes, which can be very rewarding and interesting. This can, unfortunately, also be extremely time consuming, which is one of the reasons I choose to use ready-dyed wool tops.

A vast number of colours is available from most suppliers. The colour range is phenomenal and includes soft pastels and earthy organic shades as well as the most vibrant, sumptuous hues you can imagine (the blues and greens, for example, resemble the fantastic shades and vibrancy seen in peacock feathers or on exquisite birds of paradise). These lengths of merino hang in my studio covering a whole wall like a giant paint palette of magical colours that excite the eye and are a constant source of inspiration to both myself and anyone visiting my studio (shown on pages 10–11).

As well as being beautiful to look at, merino felts beautifully and is gentle and soft to work with. It can be used very effectively as it is, or you can opt to use carders to blend it with other colours. This will give a more textured look to your piece.

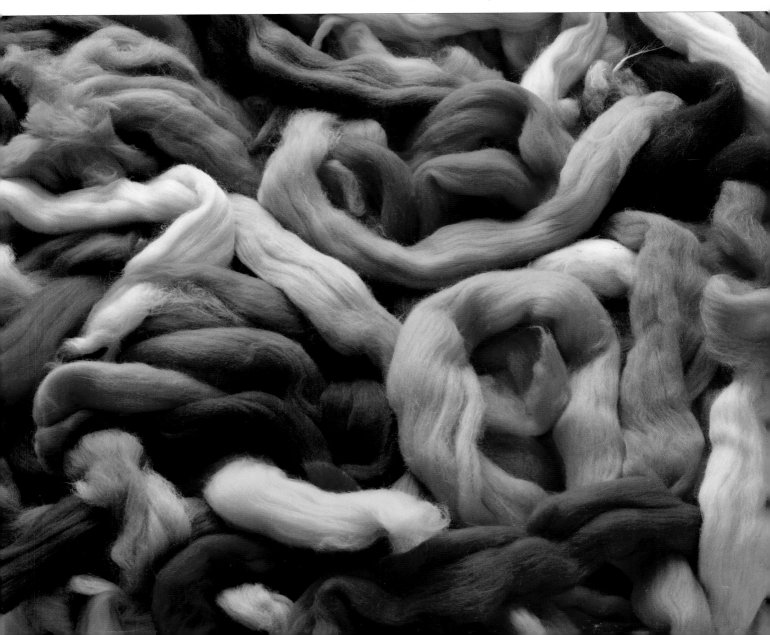

OTHER FIBRES

While merino is the main fibre used in my feltings, I combine it with a small percentage of other fibres to create different textures and effects. I often incorporate coloured silks to give an added sheen, perhaps to brighten a sky or to give the impression of a shimmering sea or river. I may use raw silk for harder areas, stones or pebbles for instance.

Suppliers often have vast ranges of all sorts of natural and synthetic by-products of the wool industry. It is great fun experimenting with these bits and pieces to see what interesting textures they achieve. Think outside the box and add tiny fragments of material found in your garden, for instance, or from everyday household products. I once used some fine pencil shavings that my son was carelessly dropping on to the table; they worked wonderfully, and felted within the other fibres well. Obviously, if you choose to add organic matter to your felt painting, be aware that this aspect of the piece can degrade. My pencil shavings will last, but if you choose to include onion skin or threads of banana fibre, for example, be sure to allow for shrinkage or the effects of moisture. You may find dried flowers and grasses a more convenient addition to landscape pieces.

Below are some of the other fibres I use in my feltings.

Angelina fibre

Angelina fibre is a unique fibre. Soft, fine and glittery, it can sometimes be heat bondable, depending on the colour. It is available in a variety of colours with an irridescent, holographic or metallised finish and, being light reflective as well as light refractive, is incredibly luminescent. Blended with other fibres, it can be used to add sparkle and highlights to your feltings. I tend to use Angelina when I want to add a tiny glimmer of light, perhaps to show sunlight hitting a roof top or a shimmering river or sea. Less is more when you are using this fibre. Too much and your felting may become glitzy and overpowering.

Bamboo tops

These are good, lustrous, pure white, silky fibres that blend well. They can add lustre to a cloudy sky, for example, or to a clean, white snow scene.

Bamboo black tops have a strong black shade and a more wool-like feel. I tend to use them to define fine lines in my pieces, using them where I would use a very thin paintbrush if I were painting. By taking off very thin strands and twisting them in your hands you can form a thread-like piece that you can almost draw with. Threads can also be used to outline an object.

Silk noil (white and dyed), Angelina fibres, gold leaf and other fibres used to embellish felt paintings.

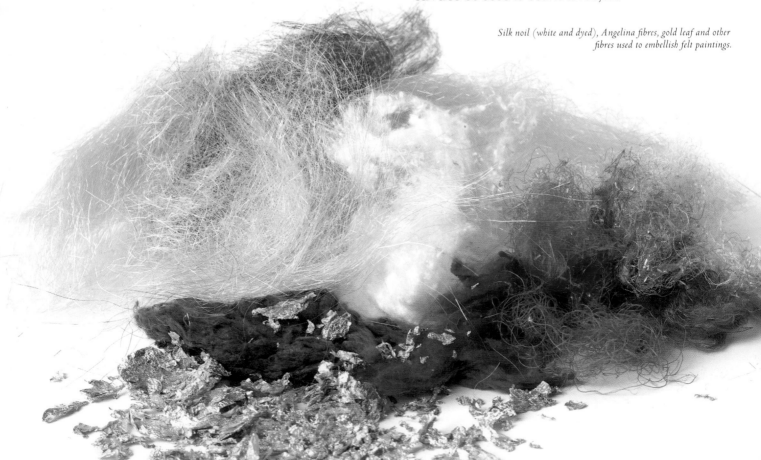

Gold leaf and glitter

Anything from regular craft glitter to lustrous gold leaf can be added to your feltings. It is a good idea to add just small amounts mixed in with fibres. Although some bits will wash away when rinsing, most will become embedded within the felt.

I like to add very tiny bits of gold leaf or glitter to some of my feltings in areas that I want to accentuate. Used sparingly, they can be detectable when viewed from certain angles or in certain lights. You may find that your felt paintings can change depending on the time of day – at night a felted sky may sparkle but appear more muted in daytime.

Wool nepps

Nepps (also known as knops) are a by-product of the woollen industry. They consist of small, ball-like pieces of fleece and I tend to use them in areas where I want to create the impression of tiny dots, such as on a sandy or pebbly beach or in the centre of a flower.

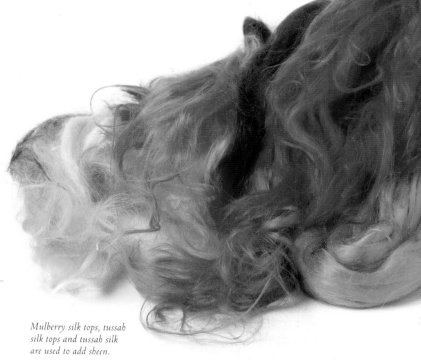

Mulberry silk tops, tussah silk tops and tussah silk are used to add sheen.

Wool nepps.

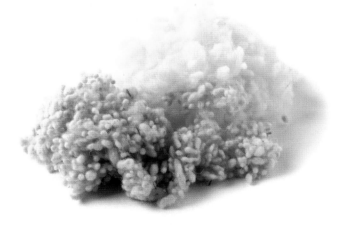

Other animal fibres

Various other types of animal fibre can be used for felting besides sheep, including alpaca, camel, yak and goat. Dog and cat hair will also felt well with merino, so it is worth saving some next time you are grooming your pet!

Merino rovings

Rovings are tops that have been drawn out into pencil-thin, continuous strands prior to twisting. They can be used to add bulk to your felting.

SILKS

Top-quality silk is one of the most luxurious fibres. It comes in many different forms and some of the less processed silks are ideal for felting.

Mulberry silk tops

Mulberry silk tops are among my favourite fibres. Soft and lustrous and in a range of glorious colours, they give exciting results when combined with merino. Their effect is to uplift an area by giving it gorgeous coloured highlights. Mulberry silk tops tend to sit on top of the merino without becoming too felted, which can work wonderfully.

Tussah silk tops

These are naturally lustrous, honey-beige coloured fibres. They are similar to Mulberry silk tops and I use them in the same way. Dyed tussah silk tops are available in a fantastic range of colours and will enhance your creations beautifully.

Silk noil

A by-product of silk, silk noil will enhance the colour and texture of your felt paintings. It is a short fibre produced from the combing of silk. It works well either carded together with other fibres or on its own when placed on top of the merino. Sold in small bags, it comes in various colours and random shapes and sizes; interesting effects can be created by simply using the pieces as they come.

I like to use the more earthy colours as additions to roads and paths in my felt paintings, and will often use green shades to enhance hills and trees. Silk noil's rough and bumpy texture can give your work a three-dimensional quality.

Linen noil consists of short linen fibres. It is similar to silk noil and I use it in the same way.

Mulberry silk noil

Also known as laps, the gorgeous quality and texture of Mulberry silk noil makes it especially suitable for felt making.

WET FELTING EQUIPMENT

Carders

The main tool you will need for felting is a pair of carders. These look similar to giant dog brushes, with handles often made of wood. The wire bristles are used to prepare uncarded wool and to blend different colours or fibres together. I look on the carders as my mixing palette where I blend colours in various amounts to make new colours and textures.

Plastic bottle

A plastic water bottle is fine to use as a water dispenser. You can buy various nozzles to screw on top like a miniature watering can for dispersing the water evenly, but you can just as easily use an awl to make holes in the bottle lid, and this will work just as well. If you are working on very fine felt paintings, it may be better to use a spray bottle.

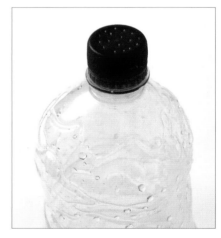

A plastic bottle with holes in the lid makes an ideal water dispenser.

Garden netting

A variety of different-sized pieces of garden netting is required to place on your picture before the wet felting process begins. I prefer to use the green garden netting available from garden centres. I have been using the same pieces of netting for years so environmentally it is a good option.

Muslin can be used instead of garden netting. It is softer on the hands and works well, but be sure to use non-dyed muslin as colour from it could transfer to your work. Muslin also has a tendency to become attached to the fibres during the felting process, so avoid rubbing the piece for too long and keep checking that the fibres and the muslin are not felting together as you work.

Bubblewrap is another option for covering your picture before you start wet felting, but it does not offer the same amount of control over the work as garden netting or muslin. The advantage of using bubblewrap is that the work will not attach to it in any way, but in the early stages of the process you have to be careful not to allow the bubblewrap to slide about on the surface as it can take your carefully placed fibres with it.

Bamboo blinds

I will always start making a piece of work by building the base layer directly on a bamboo blind. The blind offers a firm yet flexible, lightweight base that can be used to move the piece easily and safely for rolling later on. Bamboo blinds can be bought fairly inexpensively, and even found in local charity shops. Make sure you remove all metal fittings and strings, etc. before using them. Bamboo placemats or sushi mats can be used for smaller pieces, although take care if using coloured ones to wash out any excess dye from them first.

Ribbed roller

This looks very much like a regular rolling pin but is ridged. It is used to exert pressure on the fibres during the felting process, usually after the fibres have been rubbed by hand. Use it as you would a rolling pin, and remember that the more pressure you apply the quicker the fibres will bind together.

Below are the items of equipment you need for felting.

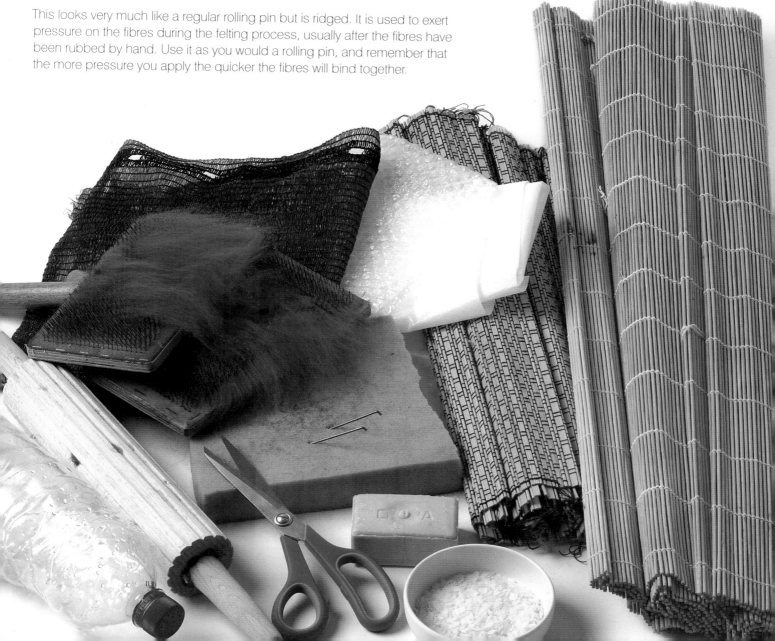

Scissors/snippers

A sharp pair of sewing scissors is essential for cutting and trimming off small pieces of fleece when creating your felt painting. I find the easiest scissors to use when working on the embroidery at the final stage of felting are little snippers with sprung handles. They get into tight areas much easier than regular scissors do and make cleaner cuts to the threads.

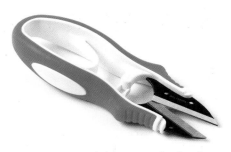

A pair of snippers is ideal for snipping threads and fibres in the later stages of your felt painting.

Soap

I generally use soap flakes, mainly because they are kinder to the skin if you are doing a lot of felting. Many feltmakers use soap (olive oil soap is a popular choice) or even washing-up liquid. All work just as well so it is entirely down to personal choice and availability.

Other equipment

Rubber gloves are not essential unless (like myself) you have a bad reaction to some soap products. They are, however, a good idea when working with very hot or very cold water. If you do not have a source of very hot tap water at hand then you will need a kettle.

Towels are handy for placing under the bamboo blind to soak up any excess water. Have large sponges around too to mop up excess soapy water and a bucket or two to squeeze the soapy water into.

NEEDLE FELTING EQUIPMENT

Felting needles

These are extremely sharp, barbed needles, so take care when working with them. They are rapidly and repeatedly poked in and out of the felt painting once dry to add more detail to the picture and to secure any fibres that have gone astray. The barbs on the needles entangle the wool fibres as they are pulled in and out.

Gauge refers to the size of the felting needle. The higher the gauge the more delicate the needle. I find the finer needles better suited to working with felt paintings. Felting needles also come with different-shaped cross-sections; triangular and star shaped. I tend to use 38 and 40 gauge needles of both shapes, but it is worth buying a selection of sizes and shapes and experimenting. You should also buy a few extra as they tend to break easily! There is a wooden-handled, multi-needled tool available that is good for working on large areas, but for fine detail you have more control when just using a single needle.

A selection of felting needles in various sizes and shapes.

Foam

When working on your felt painting with a felting needle, it is essential that you place a piece of dense foam underneath the felt, approximately 5cm (2in) deep but preferably thicker, and ideally around the size of your painting. The foam provides a cushioned backing for the needle to poke into when it comes through the felt. Without it, the needle would break and your worksurface would be damaged.

STITCHING EQUIPMENT

Sewing machine

When making marks and fine detail with a sewing machine you may have to experiment with various sized needles to find out which works best for the weight of the felt you have made. Different sized stitches can be experimented with using both straight and zigzag stitch. Machines that are capable of doing more decorative stitches can be an interesting addition to your creations, but are in no way essential. Again, it is a matter of 'trial and error' to see what works best.

Threads

When you reach the stage of final mark making (as I call it) on your work, gather together a good range of embroidery threads. I use whatever threads are available, from cotton and silk threads to wools and even thin metallic threads. In fact, try using anything that resembles a thread and can fit through the eye of an embroidery needle. The more adventurous the thread, the more interesting the final results.

For the machine embroidery, again I tend to use any threads available. Silk machine embroidery threads give a nice shine whereas cotton threads have a more matt finish that may be more appropriate for certain details. Think about the effect you want to achieve and choose the appropriate threads before starting. Again, experimentation is the key.

Sewing needles

There are no hard-and-fast rules about which needles to use – any needle should go through the felt. Try to avoid too thick a needle so as not to have small holes showing in the piece.

Iron-on backing

A self-adhesive iron-on backing is essential to stabilise your work before you start stitching. I use Vilene iron-on interfacing, but other types are available that work equally well.

Below is just a small selection of the numerous threads you can use to embellish your felt painting.

INSPIRATION

Before embarking on a felt painting, I would already have done quite a bit of preparatory work. This takes the form of photographs, drawings, paintings or rough sketches of scenes and objects that have inspired me. I then use these as the basis for the piece I am working on. Alternatively, I will gather together a collection of things for a still life and work directly from that. When I first started out, I tried to work outdoors, particularly when working on landscapes, taking my inspiration directly from the beautiful scenery that surrounded me. However, this proved too impractical with the Scottish weather. Many a time great gusts of wind would come from nowhere on a seemingly still day and the work went flying down the valley. Rain is similarly hazardous. As soon as the dry merino gets wet it is very tricky to work. I soon realised I had to work back in the safety of my studio using reference material in the form of photographs, paintings, etc. to guide me. If you are living in a warmer climate, then working outdoors is, indeed, a pleasure.

I am a keen photographer and always travel with a camera, so I now have an abundance of material to work from. It is also fine to use photographs taken from postcards, magazines, the internet and so on. I do, though, recommend using them as inspiration only; in my opinion, copying something directly can give your work a lethargic quality as less of your personal energy has been invested in it.

It is a good idea to carry a sketchbook with you, no matter how small, to capture anything that inspires you. Often, when driving down country roads, I will see a small cottage in a lovely setting that I feel would make a great felt painting. If I can, I will stop and take photographs, otherwise I will try to remember the scene and make a quick line drawing of what was positioned where as soon as I can safely do so. Sometimes, just a combination of colours can be hugely inspiring, whether on clothing, a bookcover, or even in a sky. Oil pastels are an excellent medium for making a quick visual note of colours for use in a future piece of felt painting.

......................................
Williamhope
32 x 48cm (12¹/₂ x 19in)
For fourteen years I lived in this little cottage nestled in the sloping and beautiful Border hills. When you are surrounded by hills, trees, big skies, far-off views, sheep, cows and the subtle shifting colours of the seasons, they have a way of informing and inspiring you.

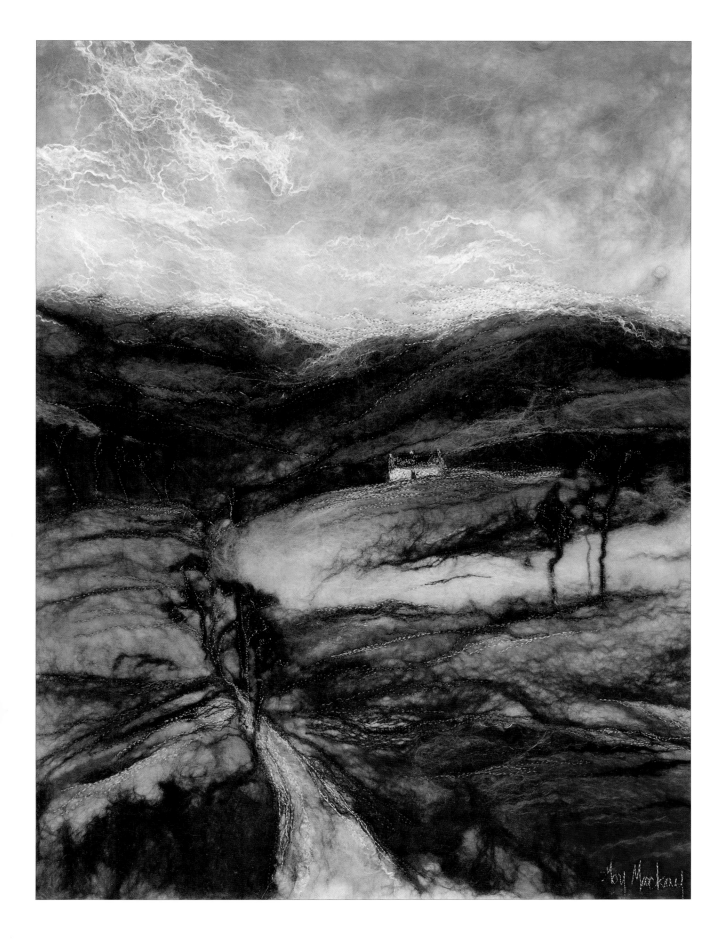

COLOUR

I have a passion for colour. It is what excites me. I believe that poor use of colour can ruin a piece; colour combinations speak volumes, and can convey a specific feeling, one that resonates beyond the actual composition itself. The aim of my work is to create positive and uplifting feelings within the viewer. Colour, for me, is communication.

I love to paint and use strong colours in my work. I developed 'felt painting' when working with acrylics. I was trying to achieve a vibrancy of colour that acrylic could not offer. I had some experience in textile dying and turned to merino. This was my eureka moment – suddenly I had the vivid palette I longed for! By choosing merino as my medium in place of paint I gained access to a huge range of exquisite and vibrant colours. Nor was I limited by the material – I discovered the fibres could be blended to create deeper, more textured shades that enhanced the painterly effect.

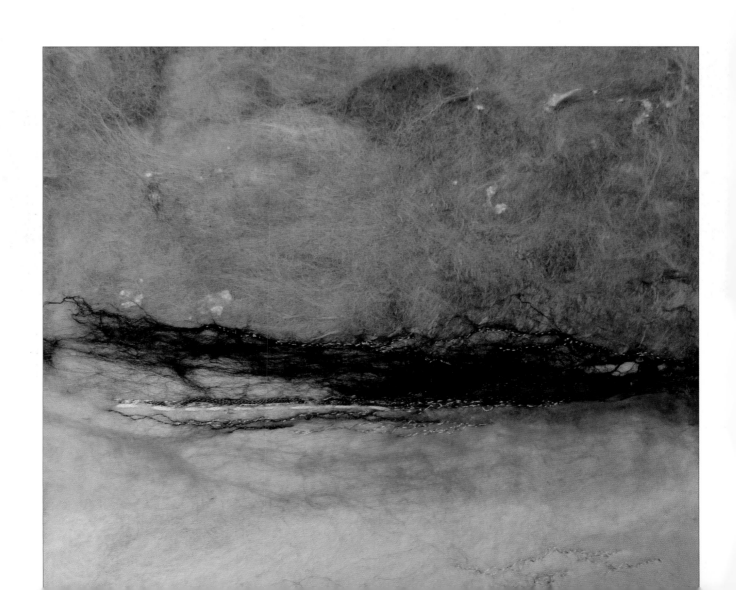

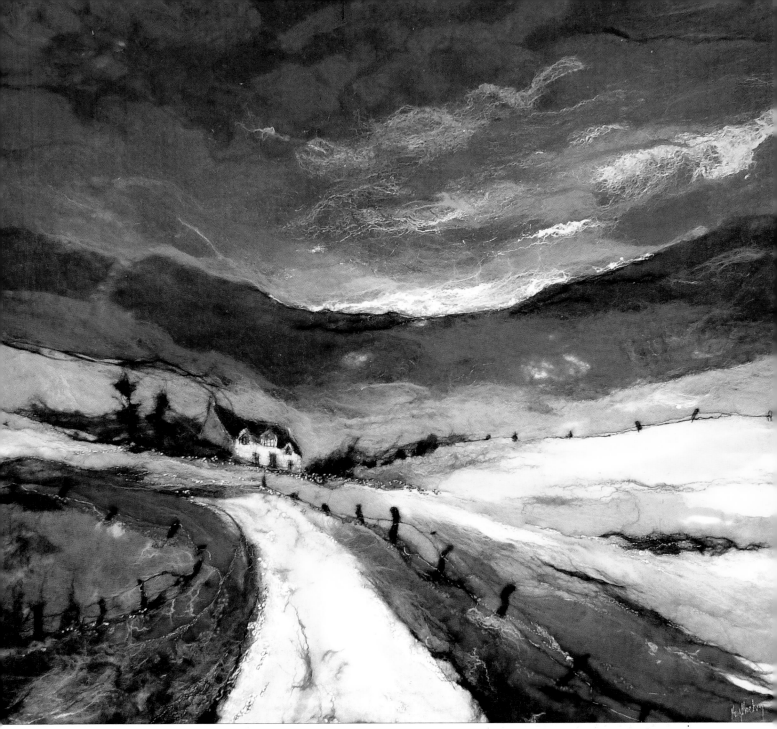

The Rugged Road to Wolf Glen (above)

100 x 100cm (39½ x 39½in)

Nestled deep in the Tweed Valley, the late summer colours here were striking. I have chosen to highlight the boldness of this season in an almost surreal way using a broad palette of colour. The more muted colours of the hills in the background contrast dramatically with the bright blues, pinks and purples of the sky, creating a sense of distance.

Reiss Sands (left)

22 x 22cm (8¾ x 8¾in)

This was actually a summer's day at Reiss in Caithness. A rain shower was in the distance making the sky a beautifully muted greenish-grey colour. I wanted to evoke the sense of lightness of sand against the darkness of sky using a subtle and limited palette. Just enough machine stitching was added to give the scene form without being over-prominent.

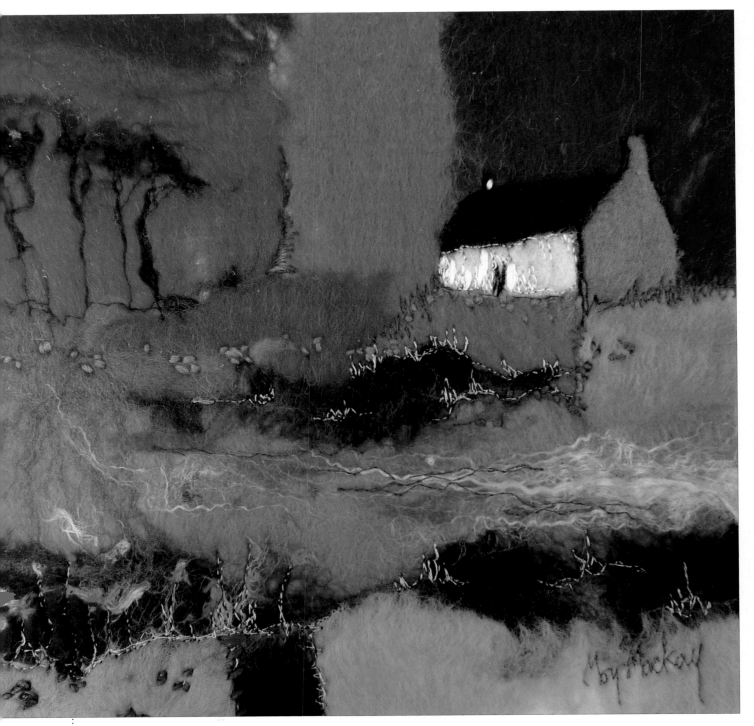

Bothy Blues

28 x 28cm (11 x 11in)

Here I have chosen a palette of similar colours, applying them in a less painterly, more abstract manner. I have cut shapes of flat colour and placed them side by side to construct a patchwork-like effect. Detail has been added by means of hand and machine stitching to give the picture depth and form.

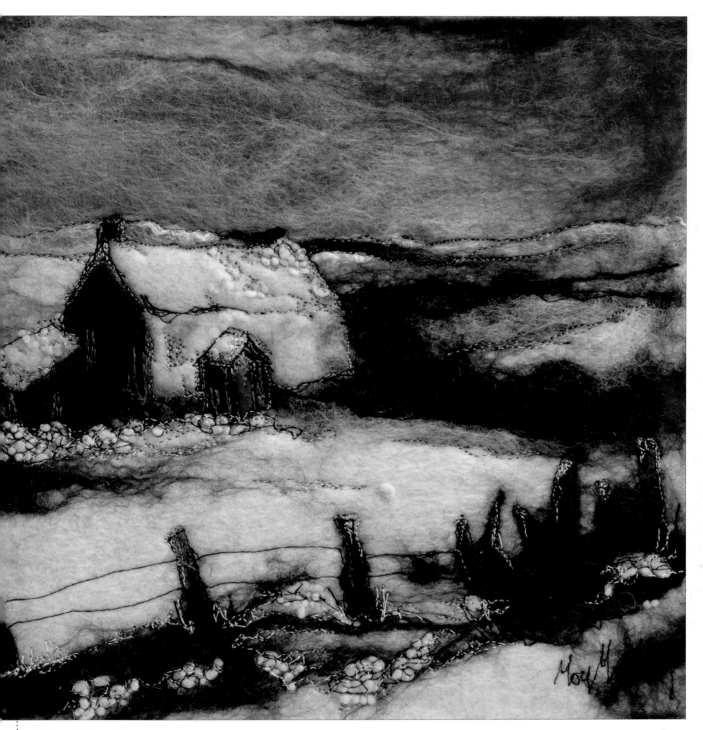

Ettrick Valley Winter

23 x 23cm (9 x 9in)

Dramatic scenes can be achieved without the use of vibrant colours. Here I have used mainly white and black to reproduce the snow-covered valley. Small areas of olive greens were then placed over the white to give a sense of melting snow. The thin blues of the sky against the white gives a nice balance and portrays the cold winter skies well.

TEXTURE

Giving texture to your work will make it come alive and give it a more realistic, three-dimensional quality. You can opt for a blend of colours that will build on texture, but there are many other ways to achieve textural effects. Lights against darks will give your work form and structure. This can then be enhanced by incorporating various fibres alongside the merino. Varying weights and types of fibres will generate an array of interesting and eye-catching textures.

Stitching as a means of mark making to define particular areas can transform your work. This can be accomplished by means of hand stitching using a host of thread-like materials in either a traditional or

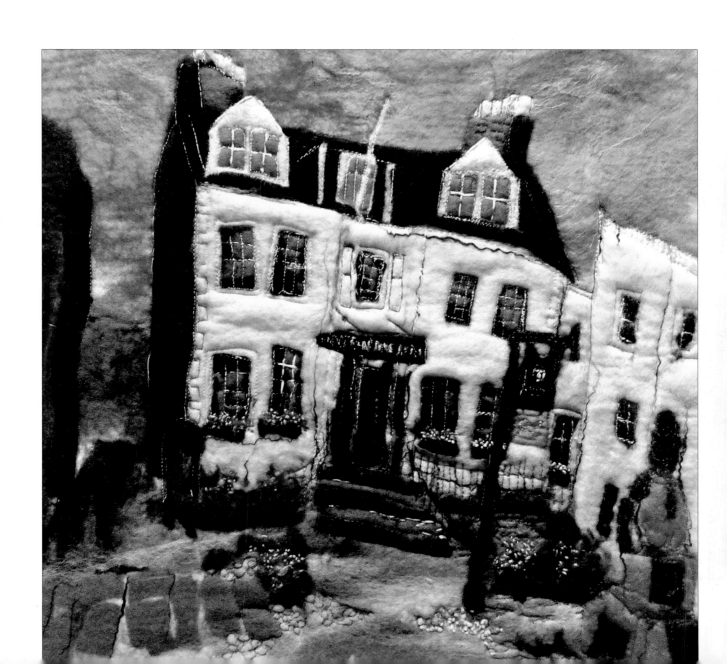

a non-traditional, more innovative way, depending on how brave you feel. Machine stitching to create marks and define areas with finer lines is also possible although not essential. Using felting needles is a clever way to modify areas of work that need a little tweak without the use of a machine.

Adding glitter and sparkle to your felt painting can produce light effects that accentuate the overall sense of perspective. Use Angelina fibre, metallic threads, gold leaf and glitter to add tiny touches of light to a starry night sky or a sparkling river or stream.

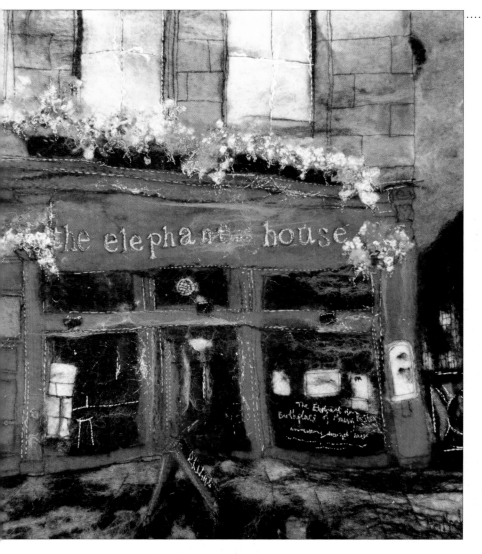

The Tontine Hotel, Peebles (far left)

46 x 46cm (18 x 18in)

It was essential to use blocks of bold, contrasting colours to create the actual shape of this building. With a piece like this, definition was important as I wanted a more realistic feel. I used machine stitching for fine-line definition along with some larger hand stitches for the paintwork, the flowers and the cobbles on the street. When embarking on cityscapes, street scenes or buildings, be prepared for the result being not as your original subject. Due to the organic nature of this medium, the fibres will move and bend freely and fairly uncontrollably. For me, this provides a more interesting and exciting end result, often adding a new energy to architectural structures.

The Elephant House (left)

38 x 38cm (15 x 15in)

Here I wanted to capture the essence of this building as a popular tourist spot. I exaggerated the flowering windowbox displays to give a natural contrast to the structure.

COMPOSITION

The first thing to think about when embarking on a painting is to consider your composition. Does it work well? Is it interesting? Is it achievable, in other words not too complex? Initally, decide what shape you want your felt painting to be, as you would when selecting a canvas to paint on. With that decided and with the picture you want to create in mind, create the base. You then need to consider the placement of the various elements. Can you envisage your idea working on the base you have prepared? If not, you may have to modify either your idea or your base. Before you become familiar with felt painting, it is a good idea to take a length of thin merino and place the outlines down roughly (like a pencil sketch) just to check they all fit in the space comfortably.

Fields of Gold

38 x 56cm (15 x 22in)

Sometimes the most simple composition can be the most effective. The bold blue of the sky in this picture has small highlights of white silk. The fields are simply a selection of similar colours. The detail, which was added last, helped to bring the piece to life by giving it a feeling of depth, in particular the fence getting smaller as it disappears into the distance.

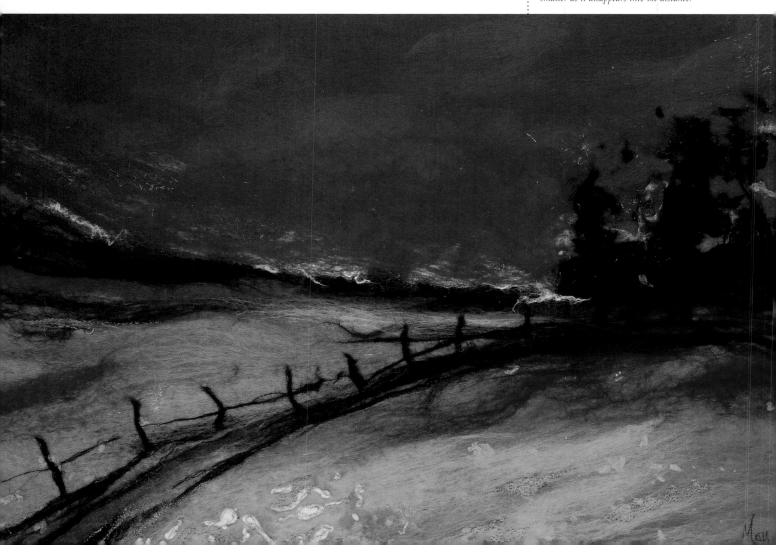

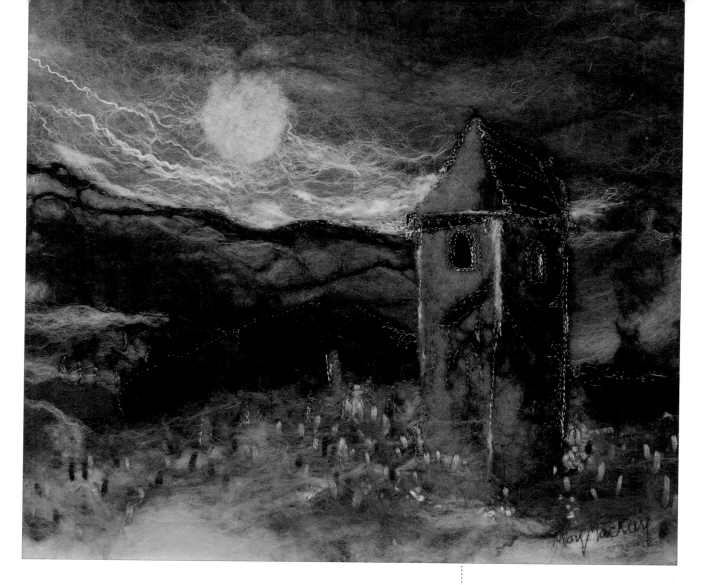

The beauty of this process is that you can place and remove elements easily, so if you feel your composition doesn't fit or work, do not hesitate to remove them and try again until you are happy with it. Having formulated your felt painting beforehand, this process is about executing that idea creatively using the medium of merino.

I always suggest starting from the background and working up to the foreground, so study your sketch, drawing or photograph and decide which elements are the farthest away and which are the closest. In landscapes, it is easier to begin with the sky in the distance and then work your way forward. Look at the colours and decide what will work best to give the impression of far-away hills, for instance, and how areas closer may appear brighter and more vibrant. Take note of the light and dark areas and endeavour to establish these within the work. Details like figures, trees, fences, and so on are added at the end once all the background is in place.

Moon over St Andrew's Tower

28 x 28cm (11 x 11in)

Having taken photographs of this tower to work from in my studio, I felt that the composition could be improved so I decided to add the moon, which worked well. Around the tower were gravestones. Rather than trying to re-create individual stones I have given the impression of them by using simple, straight stitch marks with embroidery threads. Another study of this tower is shown on page 61.

TECHNIQUES

In this section I will introduce you to the techniques I use to create my felt paintings (feltings). I will demonstrate how to prepare the merino wool tops (merino) ready for use by the process of combing and blending known as carding. From the initial stage of laying down the base (the 'canvas') on which you will work, I will then guide you through the stages of creating and laying down the colours. These will include blending your own colours, mixing fibres and adding various threads and fibres in clever ways to achieve interesting effects. The actual felting process itself, using nothing but soap and hot water, is explained in easy-to-follow steps, where all you will get is clean! Finally, I will show you how you can work into your felting by means of hand and machine stitching and needle felting.

The techniques are easy to learn and require just a few basic skills and a bit of imagination. Allow yourself a few hours to prepare your base and to create your masterpiece. The actual felting process should then take only an hour or two. Your feltings will have to be thoroughly dry before you embark on stitching and adding finishing touches, and these can take as long or as short a time as you choose.

The kitchen table can be an ideal place to work, but working outdoors where the excess water can just soak into the ground is the best workspace of all. It makes the felting task far easier but is really only advisable in warmer, still climates.

CARDING THE WOOL TOPS

The process of carding involves combing the fibres, much like hair brushing, using a pair of carders. Dog brushes or even your fingers will also do the same job on small amounts of fleece. Use the carders to comb the fibres out so that they all lie in the same direction. Carders are great for blending two or more colours together to create a new colour. The longer you card for, the more evenly blended the colours will be. For a more interesting, mottled effect, stop before this stage is reached; this will allow you to create more variety of colour and tone, and therefore more depth and texture, in your work.

The fleece on the right has been carded for longer than that on the left, resulting in a more even colour.

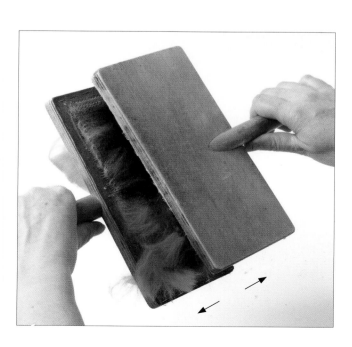

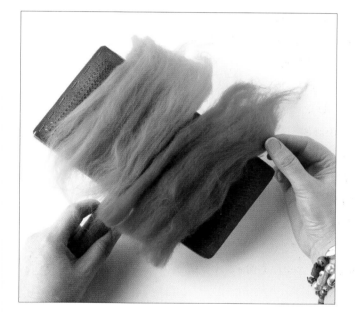

I Lay a little of each fleece side-by-side on one of the carders, so that the fibres lie in the same direction as the handle.

2 Lay the other carder on top, with the handle facing in the opposite direction, so that the needles on each carder are going in different directions.

3 Comb the fleece by firmly pulling the two carders in opposite directions (indicated by the arrows); the fleece is 'trapped' on the needles.

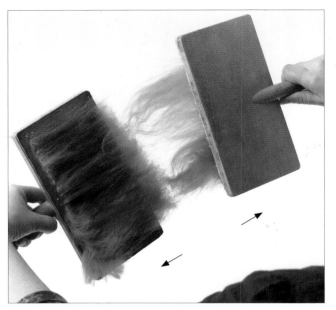

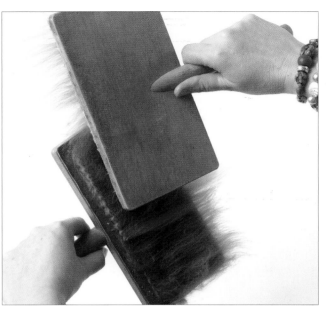

4 Pull the two carders apart, then repeat this process for several minutes.

5 To mix the colours, move the top carder higher or lower relative to the bottom one.

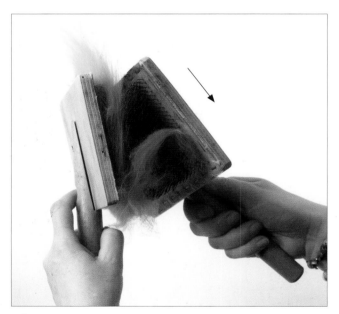

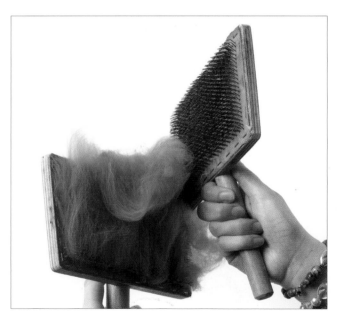

6 To remove the carded fleece, turn the top carder round so that the handles are now going in the same direction. Hold the carders together and pull the top one across the other in the direction of the arrow.

7 The fleece will be released from the top carder and tranferred to the other.

Tip

Pull the carders in opposite directions to card the fleece; pull them in the same direction to remove the fleece.

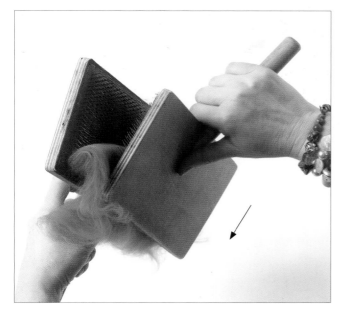

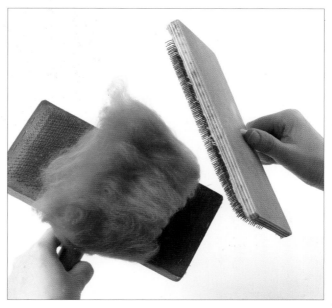

8 To release the fleece from the bottom carder, turn the top carder round so that the handles are going in opposite directions and this time push it towards you in the direction of the arrow shown above.

9 Turn the fleece through 90° and lay it back on one of the carders so that the fibres are lying at right angles to the handle. Comb the fleece as you did before in steps 1–8.

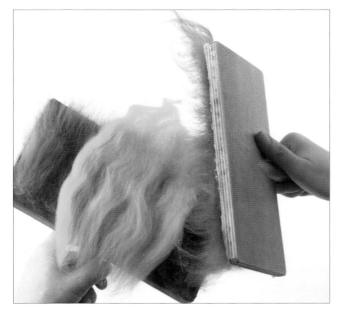

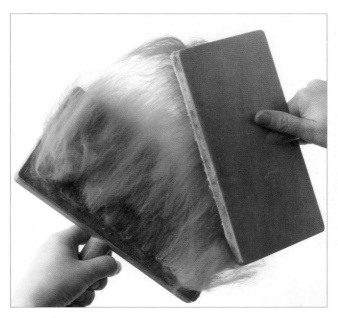

10 To introduce a third colour, separate the carders so that there is fleece on each one and place the third colour on top of one of them. All the fibres should lie in the same direction.

11 Card the fleeces (steps 1–8) several times to mix the colours together.

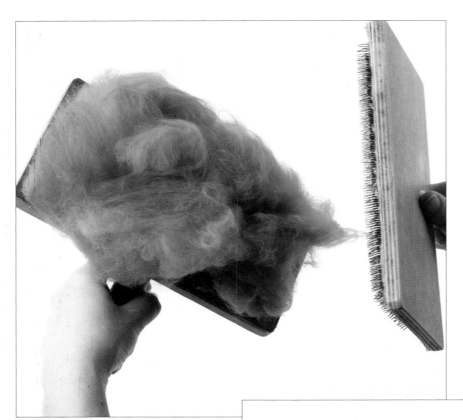

12 When you have achieved the desired mix, remove the fleece from the cards as described in step 8.

in step 8.

Tip

Experiment with mixing different colours. Vary the amount of time you card the fleece, and try mixing the colours in different proportions. Introduce different fibres, too, for example silks, glitter, sewing threads, and so on. Have fun discovering the different effects you can achieve, and using them in your felt paintings.

13 Once the colours are mixed sufficiently, you can introduce another fibre if you wish, for example Mulberry silk. Lay the fleece on one carder, tease out the fibre and arrange it on the fleece, then card in the normal way.

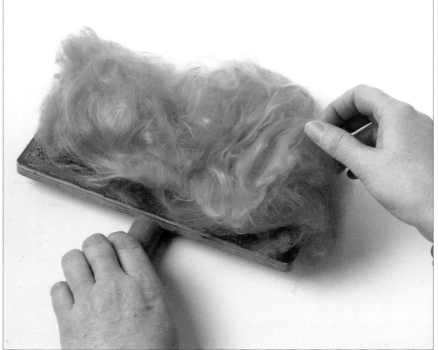

The carded fleece, with Mulberry silk mixed in.

The images opposite show a variety of different coloured merino tops and the colours they produce after carding them together. Remember that the longer you card for, the more the fibres will be mixed and the more uniform will be the end result. Carding for a shorter time will produce a more mottled effect, which you may prefer.

34

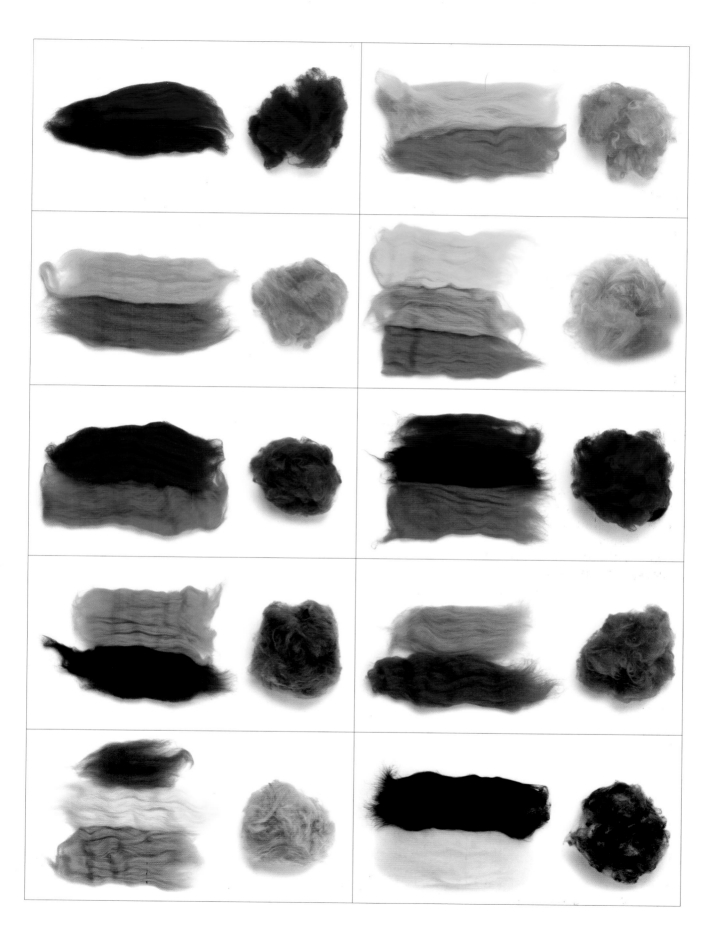

LAYERING THE FIBRES

When creating your base, work with a gentle touch. Be sure to pull the wispy fibres from the wool tops and layer them up thinly and slowly. If you work too fast and lay down thick, uneven clumps, the fibres will not matt together well and may spoil your painting.

Begin by preparing your work surface, making sure it is in a suitable place for when you start to add the water in the felting process later on (having to move a large piece of unfelted work can be tricky, so it is best to avoid having to move it at all once you have started). First lay down a towel or two on the table before rolling out your bamboo mat on top.

Choose your merino base colour. For a base I usually use white, mainly because I buy the white in bulk and I find it is the perfect base for showing off the colours to their best advantage. Sometimes I will choose to use other colours to achieve certain effects but, when starting out, I would advise you to stick to white. For a picture approximately 30cm (12in) square you will need a 1m (40in) length of fleece.

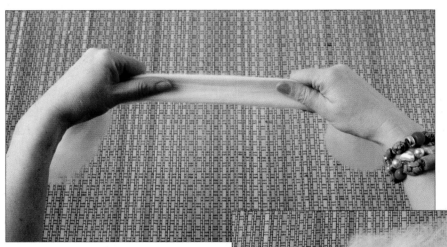

Tip
The merino should come loose very easily. If not, try lightening your touch and/or moving your hands further apart. You will find that, usually, it will not come loose unless handled gently.

I Take around a metre (40in) length of white merino and, holding it gently in both hands about 30cm (12in) apart, pull lightly to roughly halve the piece. Do this again with the two halves so you end up with four pieces. For a square picture you will need four pieces of similar length; for a rectangular picture you will need two long and two short pieces.

2 Gently tease out each of the four lengths and spread them out evenly, making sure there are no gaps. Each piece should be spread out to around 10cm (4in) wide and 1cm (½in) deep.

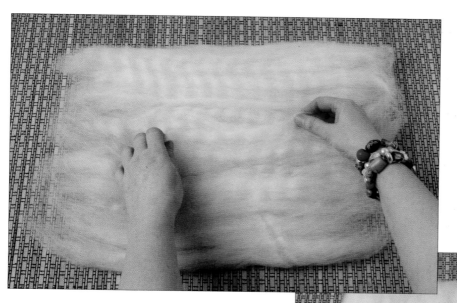

3 Start to lay down the merino to form your base. Place the first two pieces side by side with the fibres running horizontally. Carefully tease out the fibres where they meet and blend the fibres over each other to hide the join.

4 Place the remaining two pieces on top of the first two, this time laying them vertically. Blend the fibres together as before. To make a sturdier background, for a wall hanging, for example, add another two layers, each placed at right angles to the previous layer.

5 At this point, it is a good idea to select your palette of colours and fibres. For the sky, I have selected three blue wool tops in a range of tones; a blue carded wool top; a royal blue silk noil; two Mulberry silks in dark blue and turquoise; and a tiny piece of bright blue Angelina.

6 For the land, I've selected a carded, mottled green; various wool tops in turquoise, black, yellow, and subtle shades of grey-blue and grey-green; silk noil in bottle green and white; Mulberry silk in white; and a pale green Angelina.

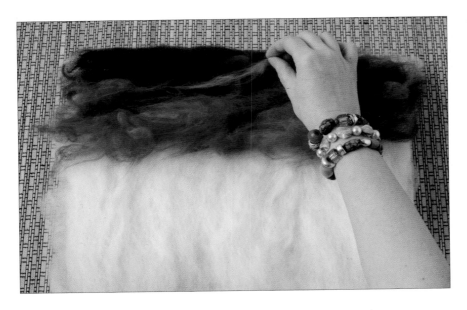

7 Starting at the top of the picture, gently pull off small lengths of coloured fibres between your fingers and place them on to your white base, just as if you were painting the colour on with a brush. Lay the coloured fleece with the fibres going at right angles to the layer below. Continue to add more colours and tones to your sky until the white is completely covered.

8 When you have layered the background colours, start to add detailing using different textures and colours. Here I have introduced a wisp of turquoise Mulberry silk with a little Angelina mixed in to suggest a cloud. Notice that the sky lightens towards the horizon.

Tip

Keep the fibres thin at this point so that the background colour shows through, as you would if you were painting with watercolours.

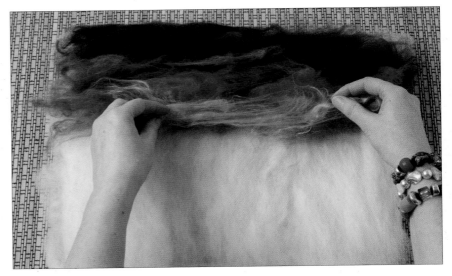

Tip

Try to keep the thickness of the fibre as even as possible; if you add a big clump of fleece between thinner, more wispy pieces then the picture is likely to end up being lumpy and uneven.

9 Moving down the picture, lay on a strip of carded green to suggest the distant hills.

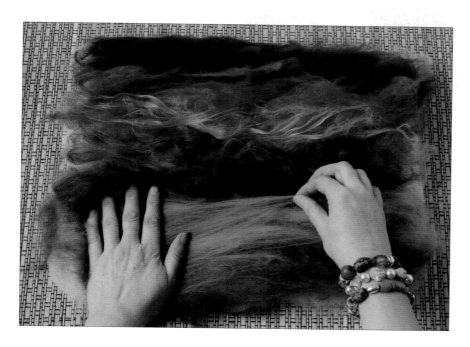

10 Work your way down the picture, introducing different colours as you go. Think about what other elements will be placed on top of the background, such as trees, sheep or flowers, and choose your colours accordingly.

Tip

Use different shades for light and dark areas – this is what will really make your work come to life.

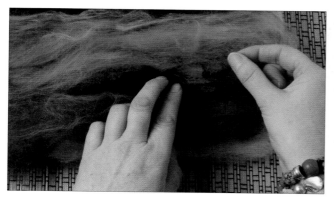

11 Once you are happy with the main composition you can start to add the finer detail. Tease out small pieces of bottle green silk noil and place them on top of the background. Remember that silks won't felt in, but will remain as distinct fibres on top of the background.

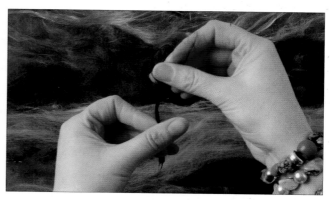

12 Start to place the main elements. To make a tree, first take a piece of black fleece and twist it at the base between your fingers.

Tip

A good technique, when laying fine horizontal strips, is to place them down on the left, hold them in place then tease the fibres across to the right.

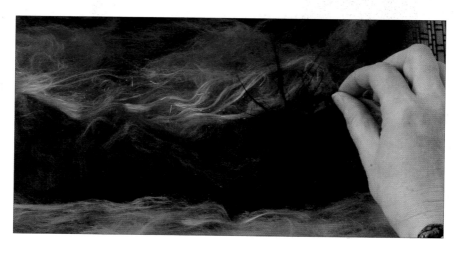

13 Lay it on the picture and separate out thin, twisted sections at the top to form branches.

14 Make the sheep out of white fleece. Tease out the fleece first, then cut out rough shapes and lay them on the background.

Tip

The beauty of felt painting is that you can play around with the fibres. Place them on, experiment, move them around, take them off. By doing this you will soon learn to see what works best to get the effect you like.

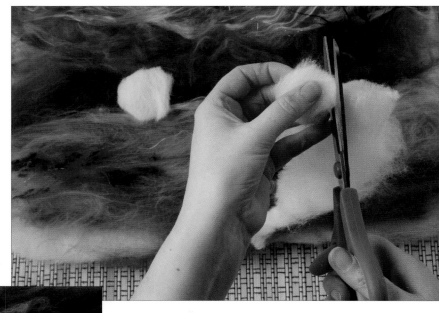

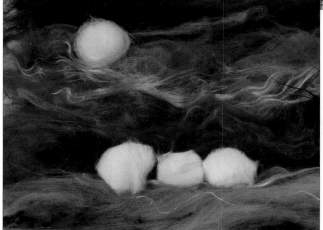

15 Make another circle of white fleece for the moon and give it a rounded appearance by laying some thin wisps of yellow around one side.

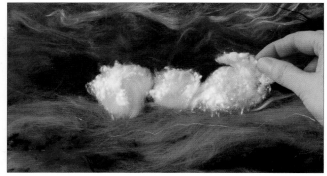

16 Give the sheep a little more texture by placing small pieces of white silk noil over the top.

17 Cut the sheep's heads out of black fleece and 'tweak' them into shape.

18 Place the heads on the sheep. Try out different angles and positions until you are happy with them.

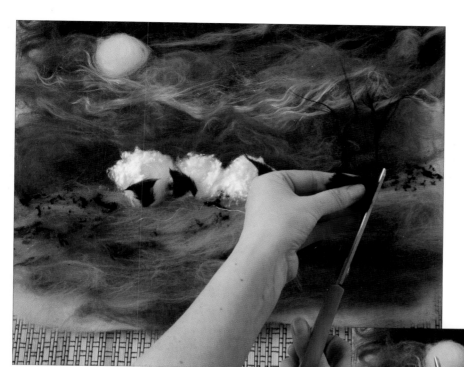

19 Once the main elements are in place you can add the finishing touches. Here, I am trimming off tiny pieces of black fleece and scattering them over the background to create texture and shadows.

Tip

Alternative types of fibres can be used at this stage to introduce more contrast to the piece.

20 To add a touch of sparkle to the wintery moon I have sprinkled on some tiny pieces of pale green Angelina.

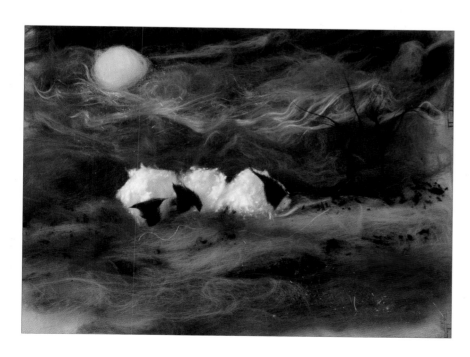

21 When you have finished, stand back and assess your picture. Add in more colour or texture here and there if you feel your picture needs it.

WET FELTING

Once you are happy with the composition of your picture, you need to felt it. Felting is the matting together of wool fibres to form a dense, stable fabric that does not fray.

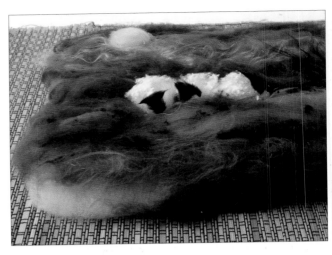

Before felting, your picture will be composed of loosely packed layers of fibres, about 5cm (2in) thick. After felting, the layers will be compacted down and matted together to form a single, dense layer.

I Very carefully, without disturbing your work, take your netting or plastic mesh and place it gently over the whole of your picture. Try to position it as accurately as possible; avoid having to remove and replace it as this can disturb the arrangement of the fleece underneath.

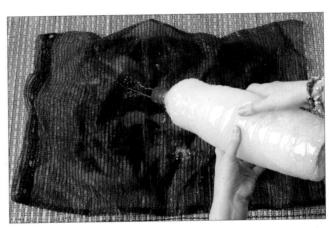

2 Take a large plastic bottle and put soap flakes in the bottom to a depth of about 2cm (¾in). Fill the bottle with hot water, screw on the lid and give it a shake to make a hot, soapy solution. Make holes in the lid (if you haven't already done so) and sprinkle the soapy water over the netting. Make sure you cover the picture underneath completely but without drenching it.

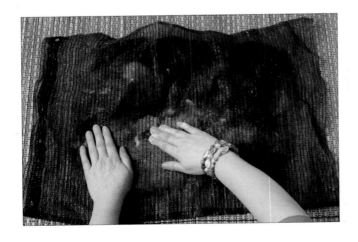

3 Lay the palm of one hand firmly on the picture to stabilise the felt, then start to rub gently, in a circular motion, over the rest of the picture. Do this all over the piece, gently to begin with then with more pressure to speed up the felting process.

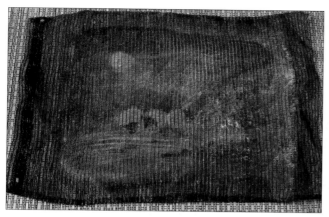

4 Continue to rub the picture all over until it has
flattened evenly. This should take about ten minutes
all together. As you work, add more soap solution to any
parts that start to feel too dry.

43

Tip

*Instead of using your hand, rub over the picture with a piece
of screwed-up bubblewrap or plastic mesh.*

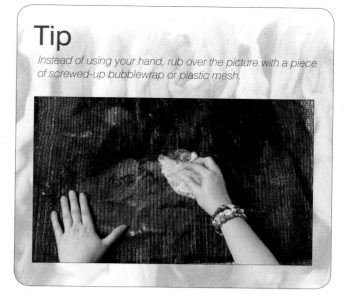

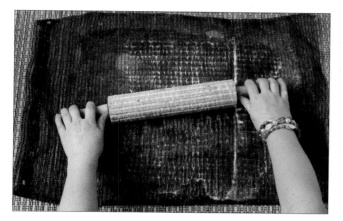

5 Roll a ribbed roller over the picture in different
directions, exerting as much pressure as possible.
Do this for five to ten minutes.

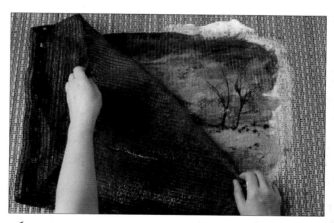

6 After flattening the piece through rubbing,
carefully peel back the netting to reveal the felted
picture underneath.

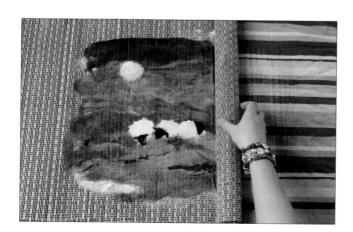

Tip

*At this stage you can gently move or reshape any pieces
that have gone astray, but it is better not to remove any
pieces completely.*

7 Roll up the bamboo mat from one side to the other
fairly loosely – roll it too tightly, and the picture may
bunch up into ridges.

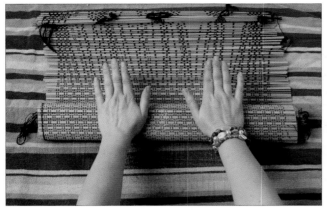

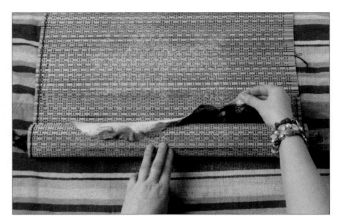

8 Turn the bamboo mat through 90° and roll it backwards and forwards for two or three minutes. This increases the friction on the felt, which helps matt the fibres together.

9 Carefully unroll the mat, easing the felt off the rolled part as you do so.

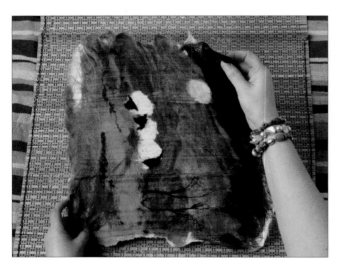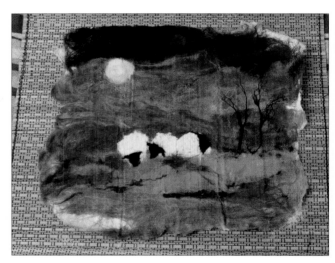

10 Pick up the felt and turn it through 90°, then roll it again as you did in step 8. Repeat this process six more times, each time turning the felt through 90°.

11 The felting process is now complete and the felt picture is ready for rinsing.

Rinsing

Rinse the felt thoroughly under a cold, running tap to remove all the soap. Rinse out the bamboo and the netting or plastic mesh at the same time. Squeeze out the excess water then place the felt in a bowl of hot water (when you roll the felt for the final time, this will help bind the fibres even more firmly). Wring out the felt one more time, then lay the bamboo mat on clean towels (or fold the old ones over) and roll the felt several times as you did before, turning it once. Allow the felt to dry, either on a washing line or over a radiator. You can speed up the drying, if necessary, by ironing the felt or using a hairdryer.

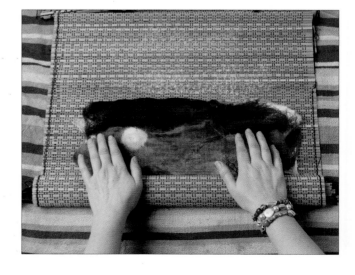

NEEDLE FELTING

Needle felting is used to add definition to the finer detail, to secure loose fibres, and to add in or reposition small pieces of felt that may have gone astray. The felting needle is used in much the same was as a sculpting tool. The barbs catch on the fibres and help bind them together. Always work on a piece of dense foam, about 5cm (2in) deep, placed under the part of the felt you are working on. This will protect your work surface and your felting needles.

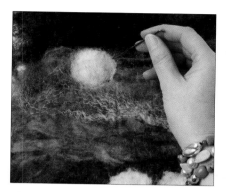

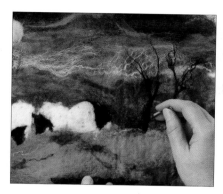

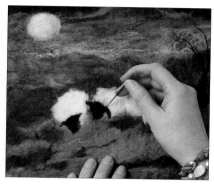

1 Redefine the moon using needle felting. Gently mould it into the correct shape using the side of the needle, and felt it in place by holding the needle vertically and stabbing it quickly and repeatedly into the edge of the moon.

2 Check for any loose silks or fibres and use needle felting to secure them to the background.

3 Use the same technique to define the shapes of the sheep's heads and to reposition any small pieces of felt, such as the sheep's ears.

4 Add eyes to all the sheep. Take tiny pieces of fleece, each slightly larger than the finished eye, and needle felt them to the background. Make a horn using a piece of black fleece, curving it round as you needle felt it in place.

5 Finally, add highlights to any parts of the picture that need brightening by taking very thin wisps of fleece and needle felting them in place. Here, I have added some orange fleece to the moon.

MACHINE STITCHING

Stitching is a means of adding definition and detail to your picture. Generally, machine stitching gives a subtler, finer line than hand stitching. It is therefore better suited to outlining, shaping and defining rather than adding details such as flowers and leaves. Start with the machine stitching, and work with the feed dog lowered and the presser foot removed so that you can move the felt around freely underneath the needle. Uneven lines suit this style of work better than straight, even lines, so avoid neat, orderly stitching. I use mainly straight stitching, but if you have an advanced machine that can produce more decorative stitches it is well worth experimenting with these.

The threads you use are down to personal choice. Silk threads have a natural sheen that will give your work a shiny finish, but you may prefer the more subtle, matt effect of cotton threads.

Before you stitch, you will need to attach an iron-on adhesive paper backing, for example Vilene, to the back of your felt. This stiffens the felt, helps protect your needle when machine stitching, and stabilises the stitches by giving the thread something to grip on to.

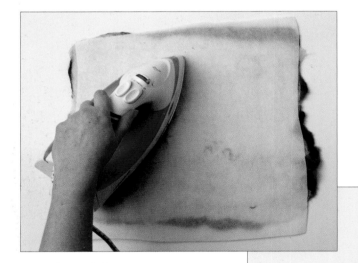

I Cut out a piece of iron-on adhesive paper backing slightly larger than your picture and iron it on to the back of the felt using a warm iron. When it has cooled, turn the felt over and iron the picture again on the front.

2 Set your machine up for free machining and, using black thread on the top and in the bobbin, stitch some more branches into the trees. Snip off the ends of the threads.

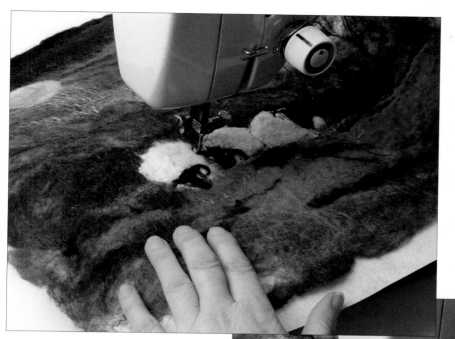

3 Using the same threads, stitch around the sheep's heads, then go around their bodies in a continuous line. This will give the sheep a better defined form and help lift them from the background. Snip the threads then move on to the eyes, laying a few stitches over each one. Take the thread across from one eye to the next and snip all the threads when you have finished stitching.

Tip

Using free machining means you don't have to worry about stitching in straight lines; in fact, more random, irregular stitching gives a better result. Use your sewing machine like a fine paintbrush, defining the detail and main elements of the picture and adding sharp highlights and shadows where needed.

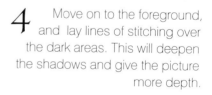

4 Move on to the foreground, and lay lines of stitching over the dark areas. This will deepen the shadows and give the picture more depth.

5 Change to cream-coloured thread and put a little more stitching on the sheep – around the heads and in the eyes.

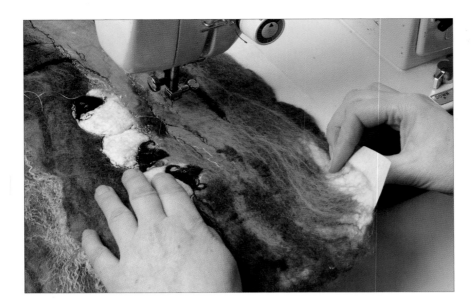

6 Rethread the machine with light green thread on the top and in the bobbin and lay some random lines of green stitching over the foreground area. Try to follow the shapes made by the fleece. When you have finished, snip off all the threads.

Tip

Choose your thread colours to match or contrast with the colours in your picture, depending on the effect you want to achieve.

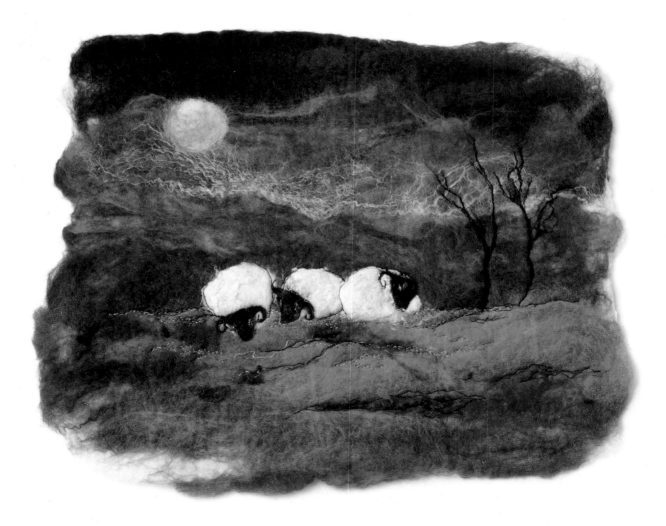

7 Your felt picture is nearly finished. All that is needed now is the hand stitching.

HAND STITCHING

As with the machine stitching, don't be too tidy with your hand stitching. The effect you are trying to achieve is one of splashes of colour rather than carefully worked detailing. The aim is to strengthen the highlights and shadows to produce more depth to your picture; further define the shapes of the main elements; strengthen the existing detailing; and add extra details such as flowers, leaves and distant birds. I use mainly doubled six-stranded cotton (twelve strands in total), which is thick enough to be strongly visible without blending in with the machine stitching. The stitches I use are simple straight stitches and running stitch.

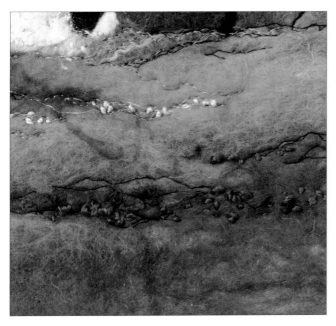 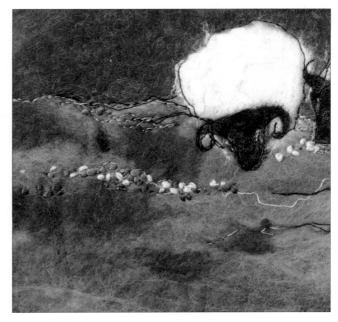

1 I have worked raised dots all over the foreground to give the impression of flowers – bright pink in the pink area, and yellow, white and purple elsewhere.

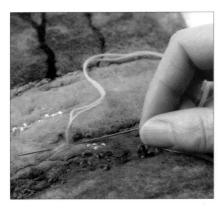 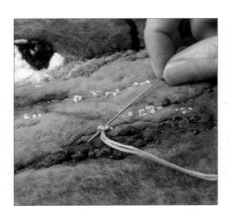 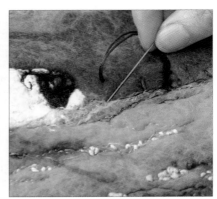

2 Small dots are worked as single, small stitches using doubled six-stranded cotton.

3 For larger dots, work four or five stitches on the same spot, changing the direction of the stitch slightly each time.

4 A line of fence posts, made using single straight stitches worked in black thread, creates a sense of perspective.

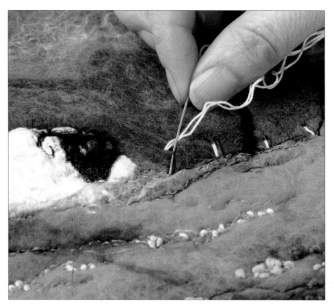

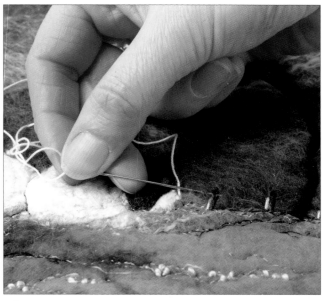

5 Highlighting the fence posts gives them a three-dimensional appearance and indicates the direction of the light. I have used single, small straight stitches placed on the left-hand side of each fence post, worked using two strands of six-stranded cotton.

6 For the fence itself I have used a single strand of cotton and weaved it across through the fleece to break up the line.

Tip

When sewing long straight stitches, take the thread just under the fleece to create a more subtle line.

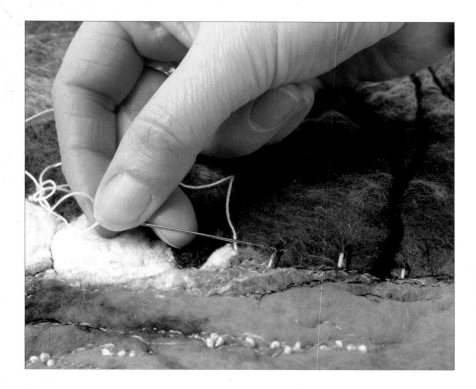

The finished fence. Notice how, by weaving the thread through just below the surface of the fleece, you create a more subtle, more interesting line than if you'd simply laid it on the surface of your work. Your aim is to create a coherent picture in which all the elements work together, so make sure you take this into account when adding the final details. Here, I have passed the fence behind the trees to place them in the field with the sheep, and followed the contour formed by the fleece.

FINISHING

Once you have finished adding finer detail and stitch marks to your felting, all that remains is to carefully trim off any excess threads. Tidy up the back of the work, too, securing any loose ends. Masking tape can be used here to prevent the work coming loose over time.

The finished piece can be used in a number of ways: as a centre piece for a special cushion, bag or waistcoat, even. You may prefer to present it as a painting. It is nice to see the rough edges of a piece of feltwork so you may want to mount it on top of a piece of mounting board without trimming the sides. Attach it by either using carpet tape at the corners or stitching on to the card. It is not advisable to glue the piece down. Box frames work well, as they keep the piece away from the glass, ensuring its three-dimensional quality is retained.

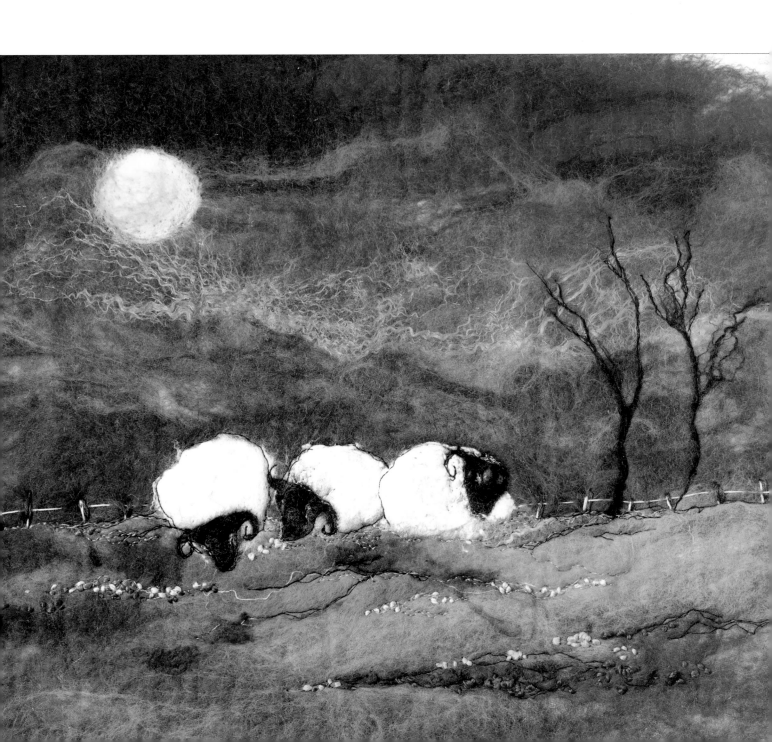

LANDSCAPES

The tactile nature of merino fibres translates wonderfully in the art of landscape feltings. They enhance skies and give a three-dimensional and sometimes changeable appearance to a picture, depending in which light the work is viewed. By blending fibres in a spontaneous way, the end results always carry an element of surprise which I personally find one of the most interesting aspects of the process.

By choosing a place that you have an affinity with you are already well on your way to creating a beautiful piece. If you are moved by what you are looking at then you are more likely to re-create that excitement within the work and produce something special.

Start with more simple landscapes, and as you progress be more adventurous by adding more to your pieces. Spend time really looking at what is around you: skies and cloud formations, distant hills compared with nearer hills. Look at the postures of the sheep and cows in the fields. How much of them is visible? Can you actually see the finer details on the trees or are you just gaining an impression of them? It's amazing what we actually start to notice on careful inspection.

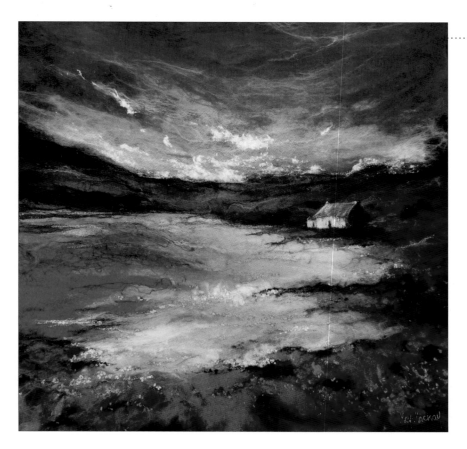

Highland Dream (left)

60 x 60cm (23 ½ x 23 ½in)

I chose some 'edited highlights' from previous works to create this piece. I love the rich blues of the sky against the earthy browns of the hills. Clear blue waters and clean white sands shine against the deep reds where the tangles of seaweed are washed ashore. Before the seaweed dries out it is an incredible shade of red, like jewels from the ocean.

St Mary's Loch (right)

27 x 34cm (10¾ x 13½in)

I worked from a wonderful photograph a friend took for this piece (with permission of course). I loved the colours of the rowan trees and the crispness of the autumn sky. I wanted to capture the vibrancy and clarity of the photograph in which the sheep and trees were reflected clearly in the deep blues of the loch.

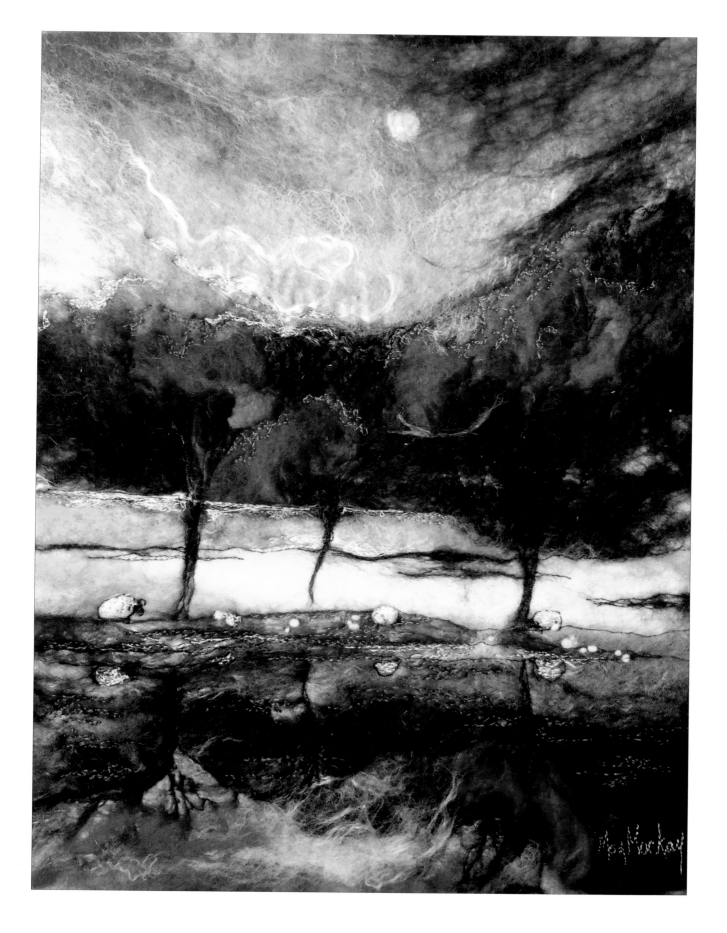

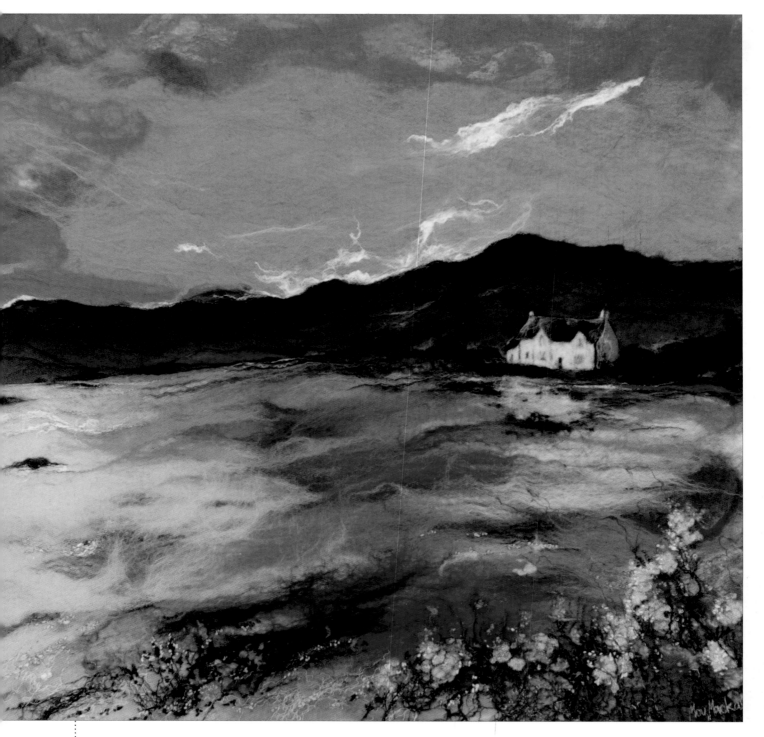

The Highland Retreat

68 x 68cm (26¾ x 26¾in)

My intention with this work was to create a sense of peace. I thought tranquil colours would convey this most effectively. I wanted to give the impression of the house reflecting in the water and achieved this by putting a similar house shape upside down within the water area and placing thin strands of merino over the top. In the foreground I used big stitches with coloured embroidery threads to give depth to the cow parsley and scarlet pimpernel.

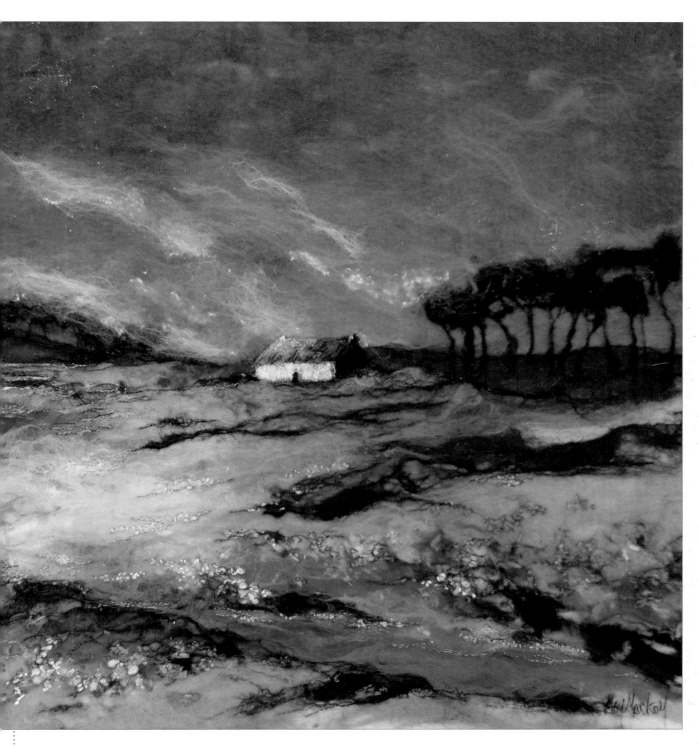

Raspberry Tangerine

58 x 58cm (22¾ x 22¾in)

These colour combinations are amongst my favourites. I love the bright blues against the ruby reds and oranges.
I have used machine stitching to add tiny stitches to the roof of the house and around the water. In the sky a smidgen
of glitter and sparkly threads have been added to make the red sky shimmer.

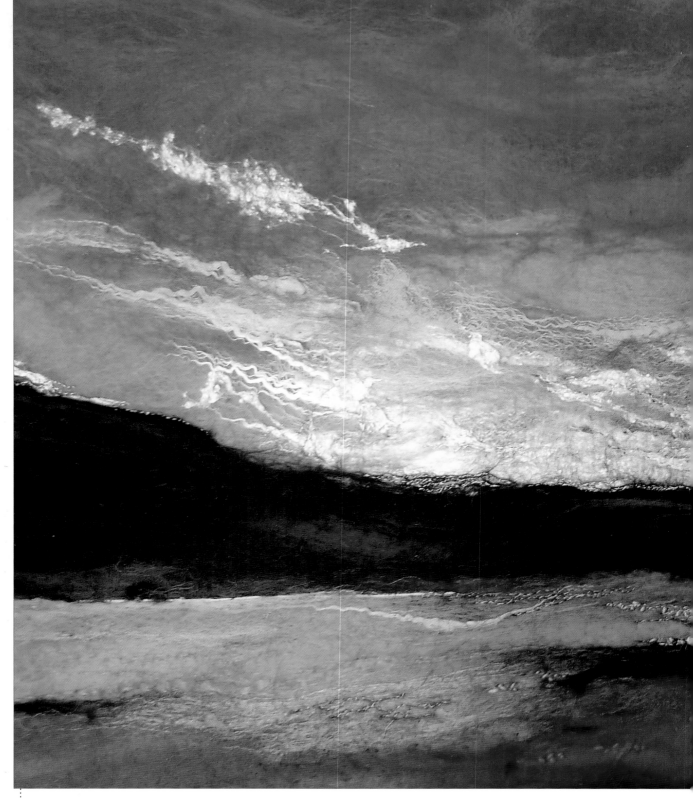

Midsummer in Sutherland

30 x 45cm (11¾ x 17¾in)

The light in the far north of Scotland is extra special, especially at midsummer when the sky remains light. I wanted to encapsulate the reflection of the midnight sky in the calm, sleeping waters.

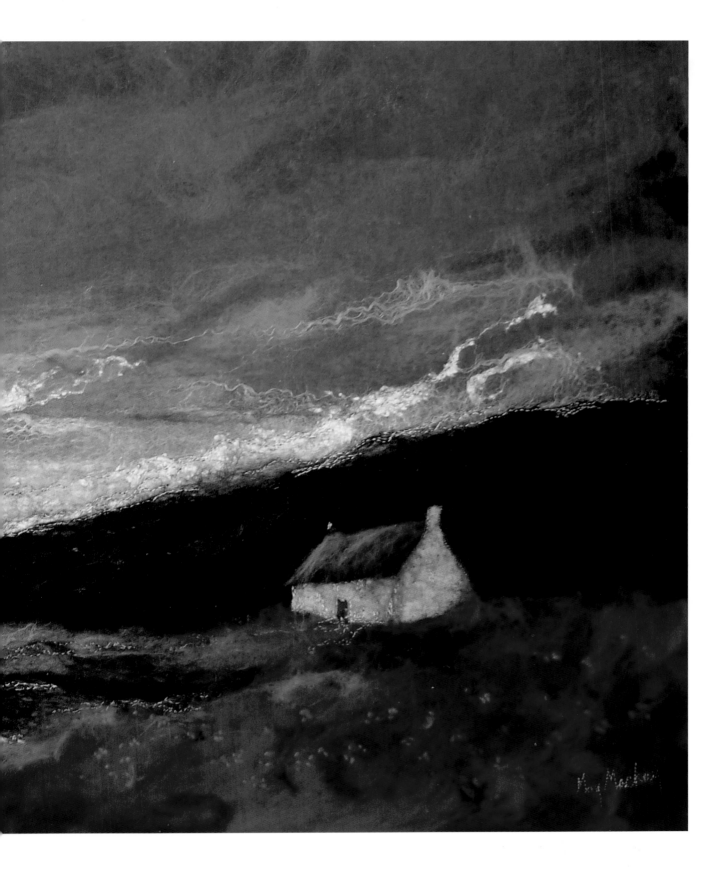

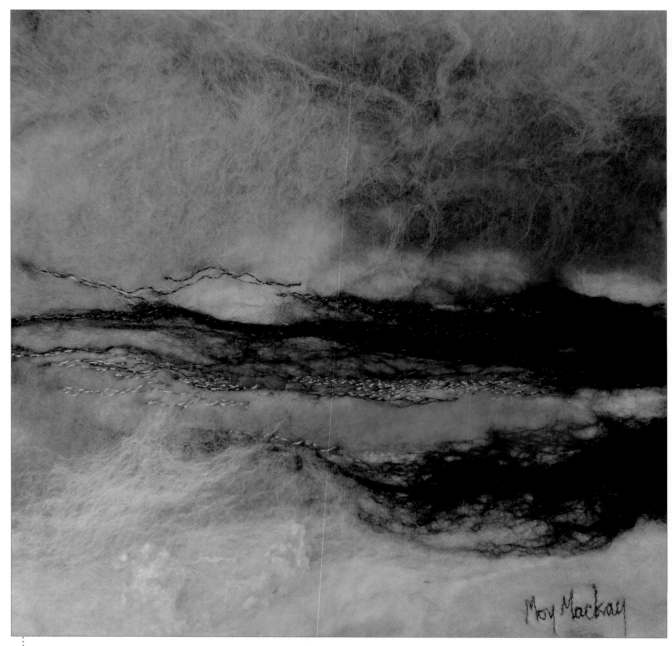

Rain Clouds over Caithness

22 x 22cm (8³/₄ x 8³/₄in)

Caithness is a place at the very top of Scotland where the land lies flat and you can see for miles. Characterised by huge, dramatic skies and rugged, barren landscapes, it is a truly inspirational place. The contrast of a heavy grey sky against white sands that I have depicted here is a common sight in these parts. I've purposely added very little detail to reflect the bleakness of the scenery, creating an almost abstract effect.

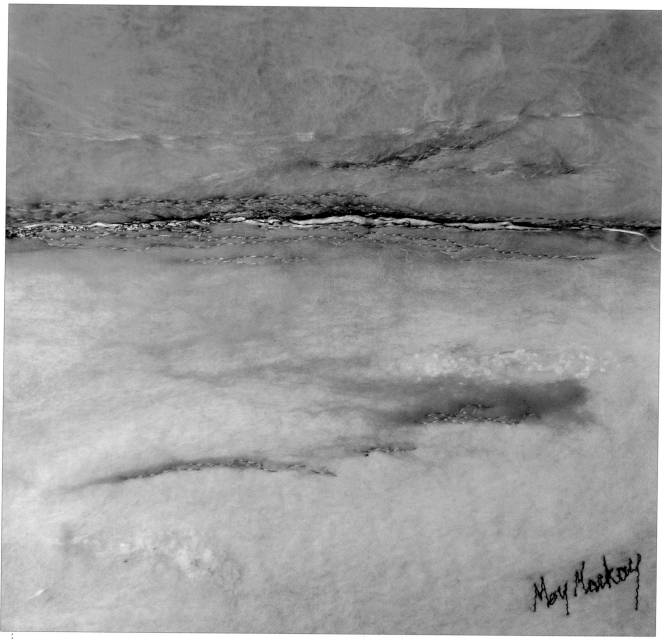

Harris

22 x 22cm (8¾ x 8¾in)

The Scottish island of Harris has some of the best landscapes in the world. The colours there seem to be infused with a magical light not seen in many other places. I adore the bright sky against the golden sand which turns into white. The colours alone were so inspiring here that I felt little need for structure.

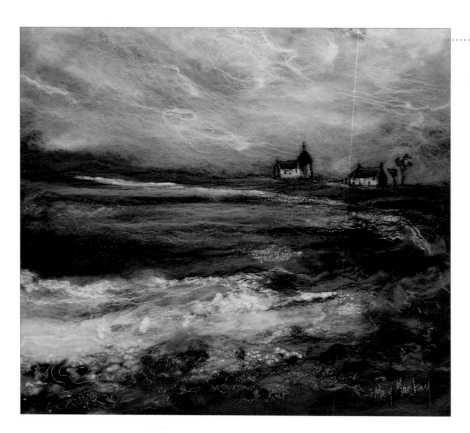

Bay of Skaill, Orkney Isles

30 x 30cm (11 3/4 x 11 3/4in)

The Orkney Isles are hugely inspiring islands for an artist. The colour and light can be stunning at certain times of the year. The skies (often heavy with rain) or a wild sea can be good starting points for a more atmospheric piece.

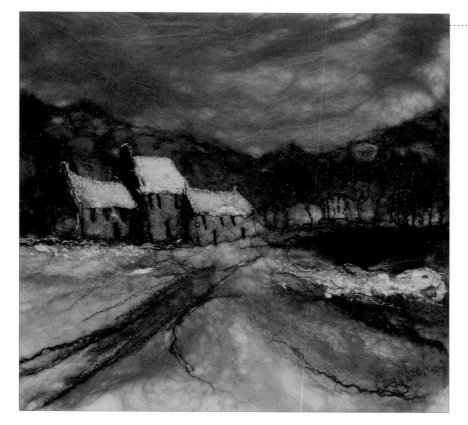

After the Snow, Perthshire

22 x 22cm (8 3/4 x 8 3/4in)

Here I worked from an old photograph I found of some cottages with the remains of snow lingering. To create a more watercolour-like appearance, I used the merino sparingly and kept the fibres thin so that more white from the base would show through the colours and make them less vibrant.

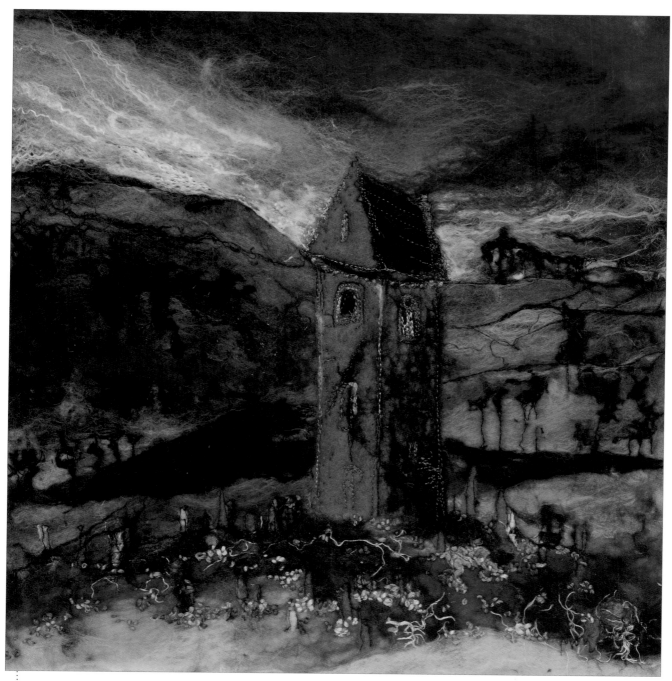

Dusk at St Andrew's Tower

33 x 33cm (13 x 13in)

This is another study of St Andrew's Tower (see also page 29). This time the sun has set behind the hills and the sky is beginning to darken, so I added a Prussian blue over the lighter areas to show this. Black merino was also used, spread thinly over the green of the fields as well as on the tower. This helped to create a more subdued feel. I chose to add the trees to give more interest to the composition. Finally, I felt some colourful stitches were needed to enhance the piece, which had become a little too sombre.

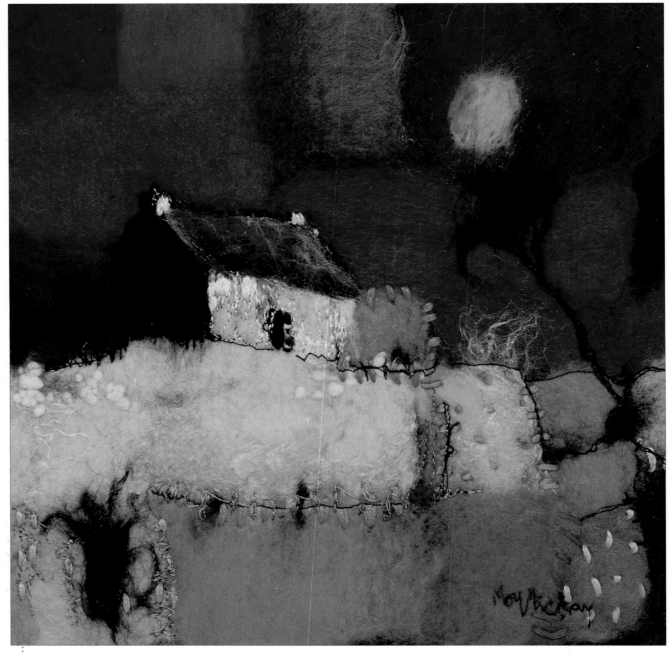

On Raspberry Hill

20 x 20cm (7¾ x 7¾in)

Experimenting with a more abstract approach in this felt painting, I have used scissors to cut squares and rectangles of flat colour and placed them side by side. The result is an interesting patchwork effect, which provides a good base to work on more decoratively with a combination of machine and hand stitching.

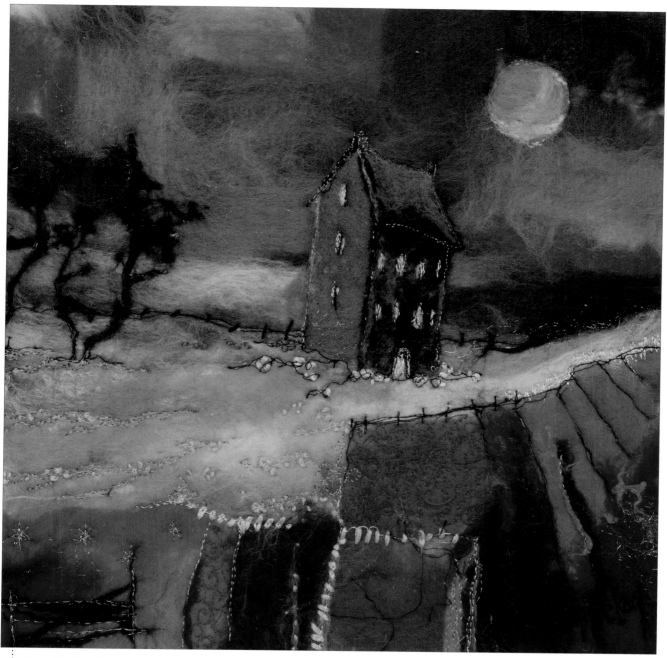

Smailholm Tower

30 x 30cm (1 13/4 x 1 13/4in)

Combining the cutting and placing of flat squares of colour along with the usual laying on of fibres resulted in an interesting piece that is neither abstract nor traditional. I like the use of the uplifting, strong colours coupled with the darkness and solemnity of the old tower house.

PROJECT: PATCHWORK LANDSCAPE

To demonstrate other styles of felt painting I will, in this project, show you how a more blocky, abstract look can be achieved. I will be using mainly flat colour, both torn by hand from the merino tops to give a natural, soft edge, and cut with scissors to introduce sharp, straight lines to the piece. I will also introduce some blended colours into the picture to give areas of texture. What could be a very basic background of simple squares of colour will then be transformed with an array of embroidery and fancy stitch marks.

Projects like this have more of a design element to them so may be ideal for those not so confident at painting. The colours and stitches you use are very much down to personal choice, so feel free to be creative and design your own felt painting based on the instructions provided. Carding can be done either at the start of the project or as the blended colours are required.

Layering the fibres and composing the picture

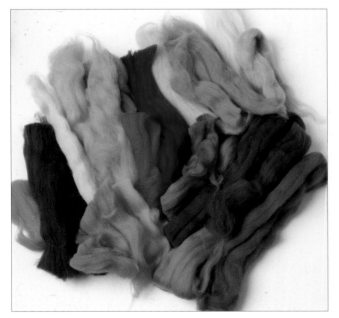

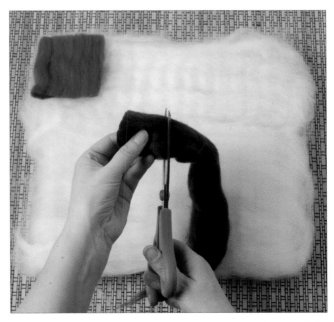

1 Begin by selecting the colours and fibres for your picture. For this project I have chosen a good range of blues for the sky and various oranges, pinks and greens for the land. Altogether, I have used about twenty different colours, as well as some white wool nepps, yellow and blue silk noil, dark blue Mulberry silk, and bright blue and green Angelina.

2 Lay out a square base, about 30 x 30cm (12 x 12in), using undyed fleece. Take a length of uncarded blue fleece and cut off a square using scissors. Tease out the fibres a little by hand and lay the square in the top left-hand corner of the sky.

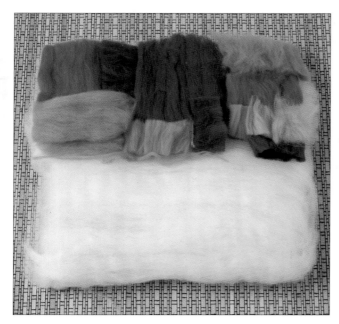

3 Continue to build up the sky, cutting squares and rectangles of fleece in various shades of blue and laying them side by side, with the fibres running either horizontally or vertically. Overlap the blocks slightly to create a patchwork effect. The white base should be completely hidden underneath.

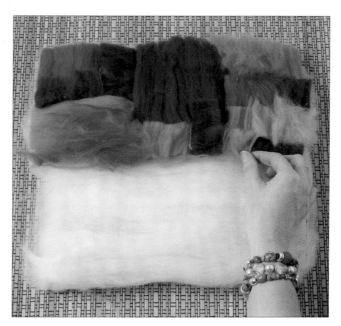

4 Lay some thin strands of carded turquoise fleece over the lower left part of the sky, and cut off smaller squares of fleece to fill in any gaps.

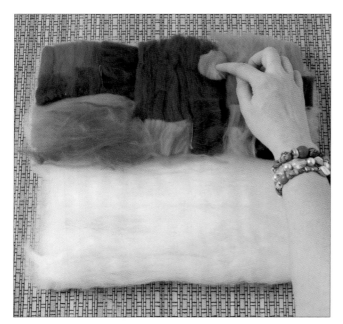

5 Cut out a circle of uncarded orange fleece to make a sun. Place it gently in the sky and lay a thin wisp of yellow over the top.

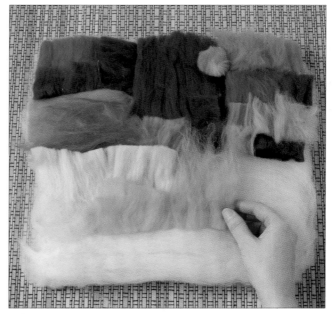

6 Continue down to the lower part of the picture, laying on a patchwork of fleece in yellows and oranges in the top left-hand corner of this area. Tease out the fibres from one or two of the fleece patches and lay them vertically to create the impression of a cornfield.

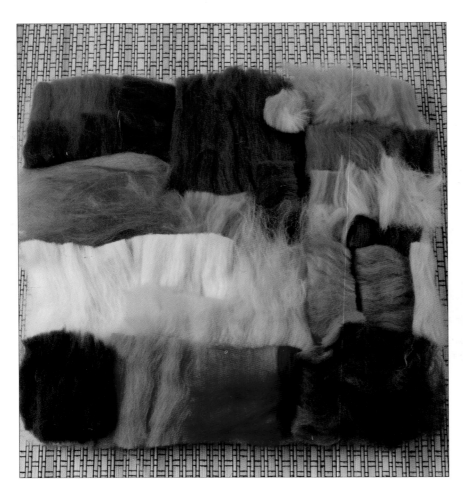

7 Complete the lower part of the picture using different colours to create a vibrant patchwork of fields. Notice that I have incorporated some patches of mottled green, created by carding together two different green shades.

8 Create small patches of shade by laying darker tones over lighter tones of the same colour. Pull out the fibres of the top layer so that the lighter colour underneath is visible.

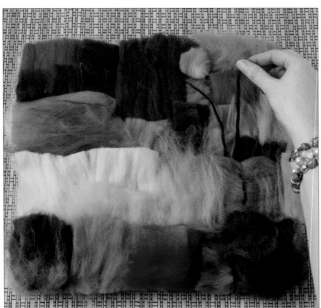

9 Make the trees by rolling thin strands of black fleece between your fingers. Lay the strands on the picture, tucking the ends behind the tops of the fields.

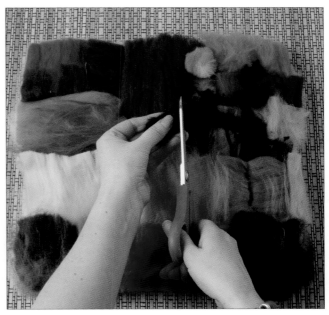

10 For the foliage, take some black fleece with a little green fleece carded in and cut it up into small squares. Roll them gently and trim off small pieces, sprinkling them straight on to your picture.

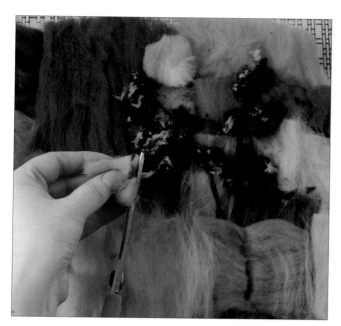

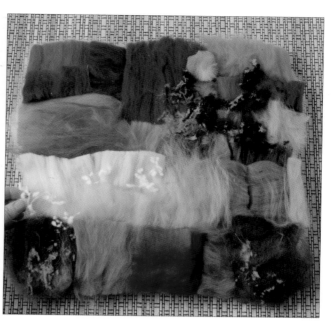

11 Repeat using bright green, scattering the trimmings thinly amongst the dark green foliage to create highlights.

12 Continue to add the finer detail. Sprinkle more of the bright green cuttings over the green fields to create patches of light, and place some turquoise cuttings around the trees to help them stand out from the background. Finally, take some white wool nepps and lay them over the lower parts of the pale yellow fields to create texture.

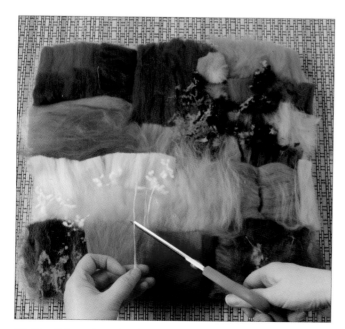

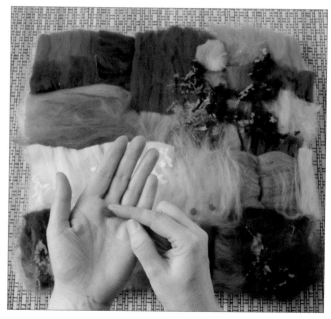

13 Take a length of yellow silk noil, twist it tightly between your fingers and lay it on to the picture in 5cm (2in) lengths over the bright yellow field.

14 For poppies, roll tiny pieces of red fleece into balls. Lay them on to the orange field.

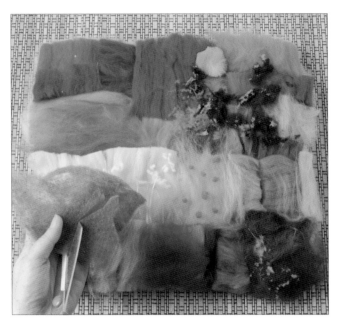

15 Take a piece of thin, grey fleece and cut out the shape of the front of the chapel.

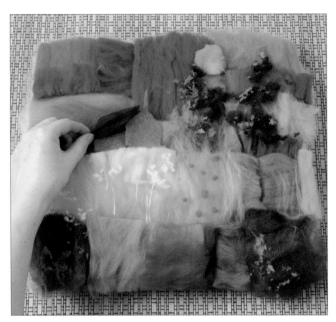

16 Lay it on to the picture, tucking the edge just behind the fields, and cut a second piece for the side of the chapel. Make the roof from a piece of thin, black fleece and position it on the picture.

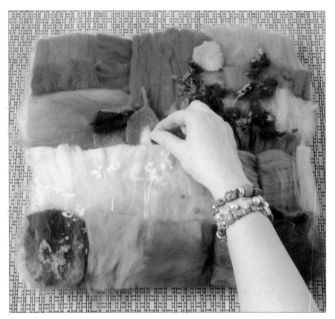

17 Cut the door from a tiny piece of white fleece, and lay a grey highlight along the top of the roof so that it stands out from the sky better.

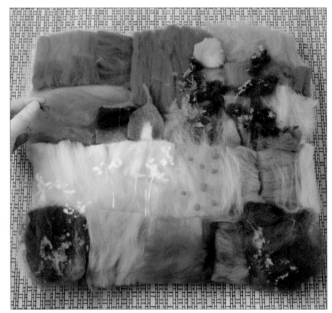

18 Add more texture to the sky by sprinkling on some blue silk noil.

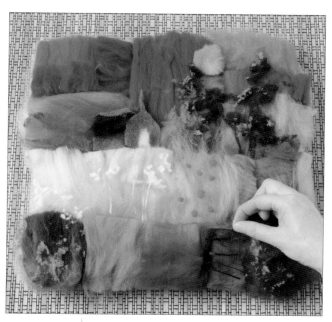

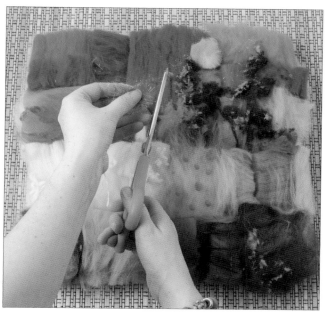

19 Cut short lengths of dark blue Mulberry silk and lay them horizontally across the turquoise field.

20 Finally, sprinkle fine cuttings of bright blue and green Angelina around the trees. Your picture is now ready for felting. Felt the picture following the instructions on pages 42–44.

Refining the detail using needle felting

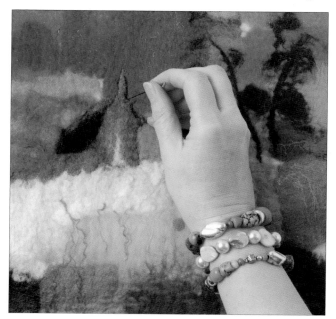

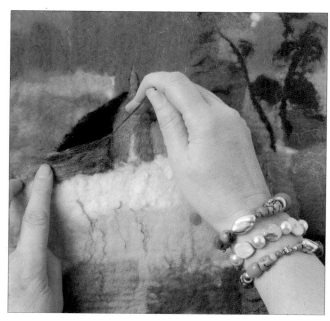

21 Redefine the shape of the chapel and reposition any small parts you're not happy with. Stroke the fleece with the side of the needle to mould it into shape, then secure it using needle felting.

22 Add a little more black to the roof and a mix of white and grey to the side of the chapel.

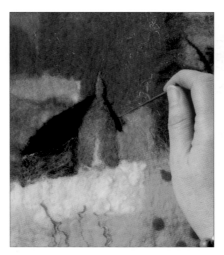 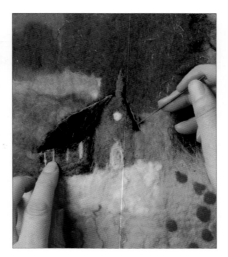 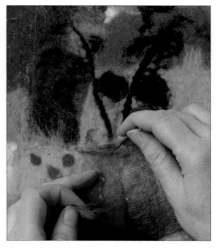

23 Take a tiny piece of black fleece, twist it and use it to define the right-hand edge of the chapel.

24 Using small pieces of white fleece, put in the windows and door. Use fine wisps to lighten the colour of the roof a little and give it some depth.

25 Add in a little more blue where a gap has appeared during felting (this often happens with patchwork pictures, particularly where the patches are non-overlapping).

Tip

When adding in details, always use larger pieces of fleece than you actually need and cut off the excess once it has been needle felted in place.

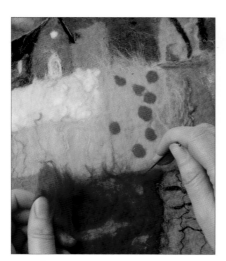 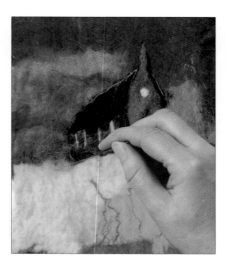 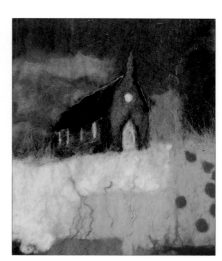

26 Cast your eye over the picture and fill in any other gaps you can see with a suitable colour.

27 Add a patch of bright yellow at the edge of the chapel and extending along the horizon to soften it and create an interesting effect.

28 When you are happy with your picture, it is ready for stitching. Remember to attach the iron-on adhesive backing first (see page 46).

Machine stitching

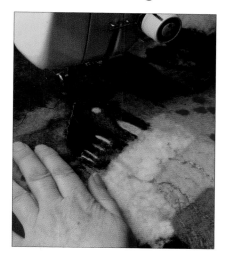

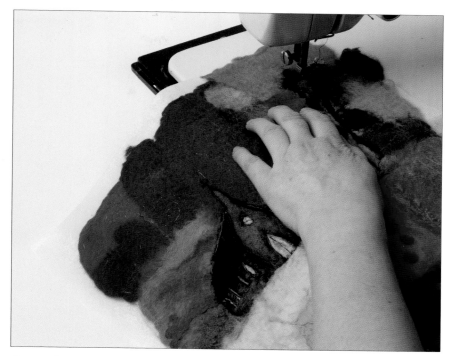

29 With black thread on the top of the machine and in the bobbin, begin by defining the chapel. Put in the cross, then outline the building, each of the windows and the door. Run some random stitching vertically down the roof to give it form. Snip off the threads.

30 Run some stitching along the horizon line, beginning on the left-hand side of the picture. Every now and then, take the stitching up 1–2cm (about 1in) then back down to the horizon to create a fence post. Continue the line of stitching up into the trees and add in some more branches.

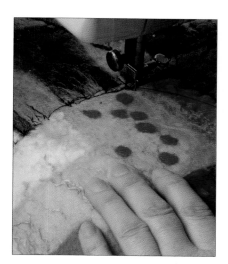

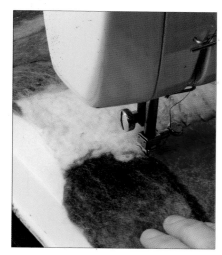

31 Outline the pink field, creating fence posts as you did along the horizon.

32 Continue to outline more, though not all, of the fields on the right.

33 Snip the threads, then outline some fields on the left. This stitching will help define the fields and add to the patchwork effect.

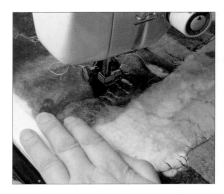

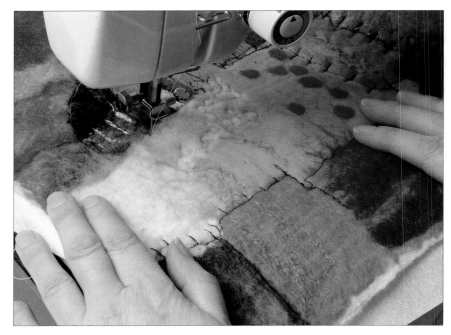

34 Change to cream thread on the top of the machine and in the bobbin, and lay a line of stitching through the centre of the round window on the chapel, down the middle of the door and around the windows.

35 Outline the pale fields on the left of the picture, and enhance the texture of the white patches by stitching around the nepps in a circular motion.

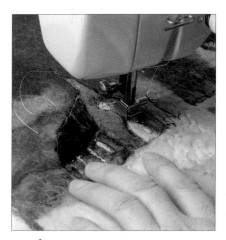

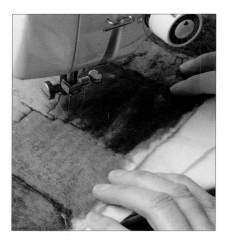

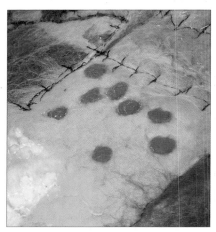

36 Change to a gold-coloured metallic thread on the top of the machine and in the bobbin. Place some gold stitching around the windows and door, on the cross and around the outline of the chapel.

37 Run a line of gold stitching down the side of one of the dark pink fields, working in a zigzag motion.

38 Roughly outline some of the red poppies in the yellow field.

Tip

You don't have to follow my design exactly – by using your imagination and altering the colours of the fleeces and threads and the positioning of the stitches, you can create a picture with your own, unique 'stamp' on it.

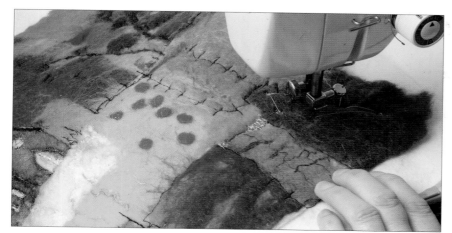

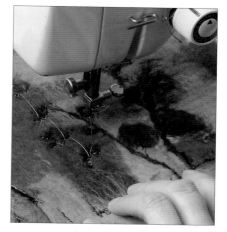

39 Change to light green thread on the top of the machine and in the bobbin and place some tiny patches of green in the dark green field, each made by working several stitches on top of each other. Take some of the stitching across to the top edge of the turquoise field, working it in a random, zigzag motion. Snip all the threads at the end.

40 Place some green stitching within the lightest parts of the trees to brighten the highlights.

Tip

Keep your hand stitches large, irregular, almost clumsy looking – too neat and tidy and they will blend too closely with the machine stitching.

Hand stitching

For all the hand stitching I use a doubled six-stranded cotton. Use it to add detailing to the fields in the form of simple flowers and plants, and to suggest that the patches are stitched together.

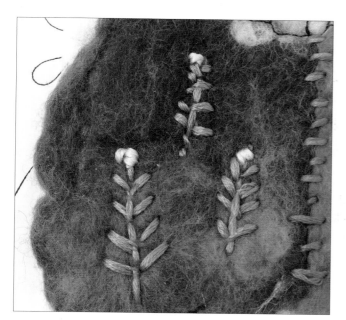

41 On the green field, bottom left, create some simple flowers in stitch. The stems and leaves are worked as straight stitches in green thread, and the flowers as three or four stitches overlaid at the top of each stem.

42 On the bright pink field, next to the green field, stitch randomly placed crosses using purple thread, and work a single raised dot in deep pink in the centre of each one. Use the same deep pink thread to lay uneven straight stitches down the left-hand side of the field.

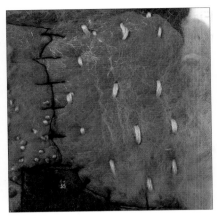

43 On the dark pink field to the right, work dots of deep pink by overlaying several stitches, distributing them randomly over the felt. Lay some orange stitches across the boundary between the dark pink and the turquoise field next to it, then work pale green stitches over the top. Start with a simple running stitch then lay straight stitches at right angles to it over the top.

44 Work the pale green running stitch around the top of the turquoise field, taking some of the hand stitching under the machine stitching here and there. Also place a few long, pale green stitches in the lower right-hand corner of the field.

45 In the turquoise field just above the dark green field, work random, vertical straight stitches in turquoise thread.

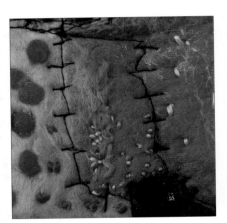

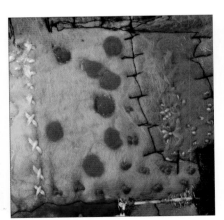

46 Moving to the left, combine light and dark pink threads and work small, densely packed raised dots in the lower part of the bright pink field.

47 Stitch larger raised dots in the lower right-hand corner of the poppy field using red thread. Work a row of yellow cross stitches down the left-hand side of the field.

48 Stitch raised dots on to the yellow field. Use gold thread for those around the chapel and white thread within the light areas to strengthen them.

Finishing

Finish the piece following the guidance on page 51.

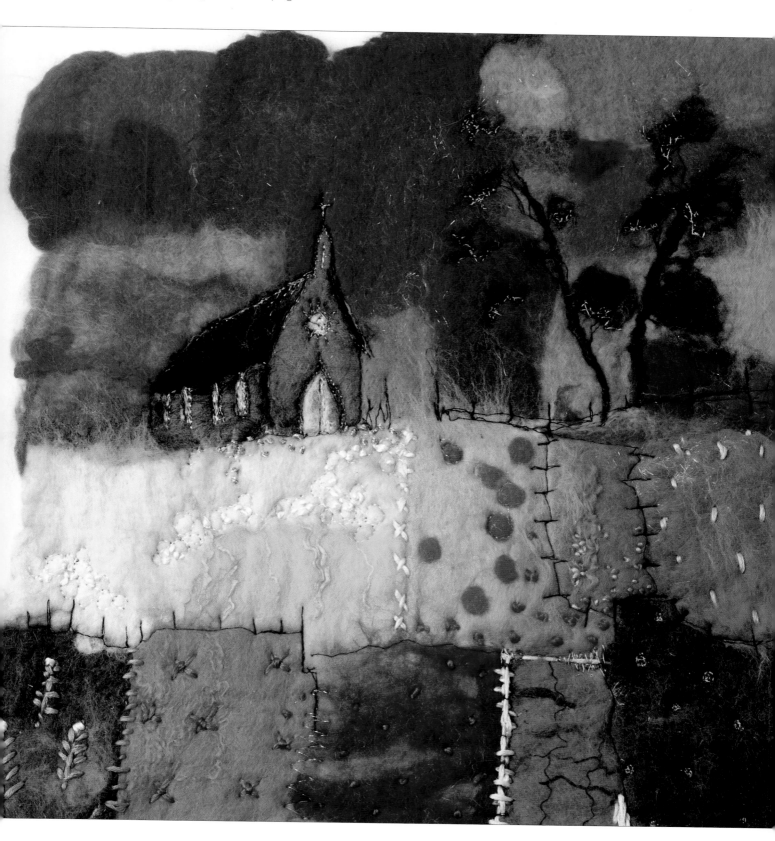

BIRDS

Birds are a passion for me at the moment and I have really enjoyed creating these pieces. While the background can be very loose, free and simple you may discover that the birds themselves are harder to realise. Do not be discouraged by this as the needle-felting technique is especially good for revival in the final stages. It is possible to recover or add detail to your bird if it happens to have reshaped itself en route!

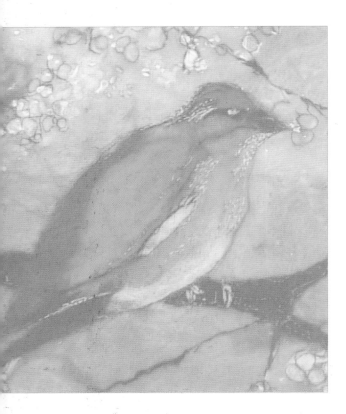

Waxwing with Cherry and Lime Blossom

60 x 36cm (23½ x 14¼in)

For the blossom I have cut small pieces of pink tussah silk and, for the white blossom, white tussah silk that was rolled into small balls and laid down. Black tussah silk was used for the branches, which will independently give the wavy effect shown here. Small, green, stitched dots were added at the final stage for more texture and interest. The bird itself was achieved by initally cutting out the whole bird shape in grey merino. After this, the additional colours were laid on top paying careful attention to the specific markings of the bird. By machine stitching, the bird shape became more defined.

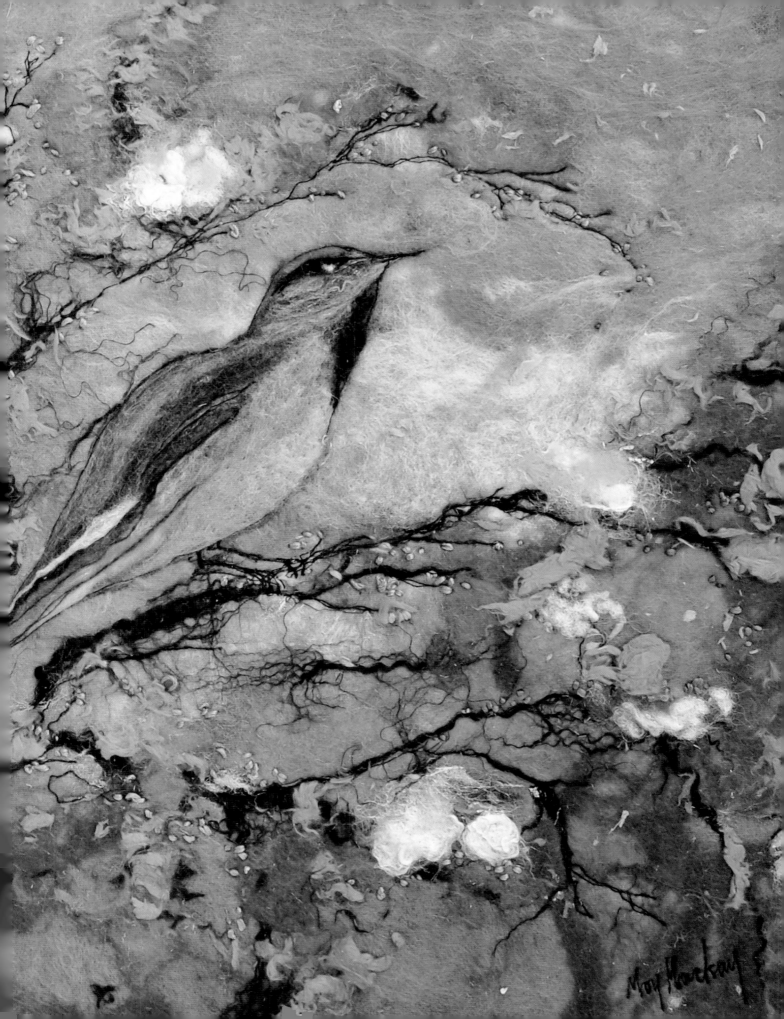

Berry Feasting Blackbird

44 x 30cm (17¼ x 11¾in)

Having trained as a textile designer I composed this piece with the design aspect in mind. I love the ochre shades against the stark black. The berries I decided to infuse with bold, thick threads to kindle more of a design element, which I feel brings the piece to life.

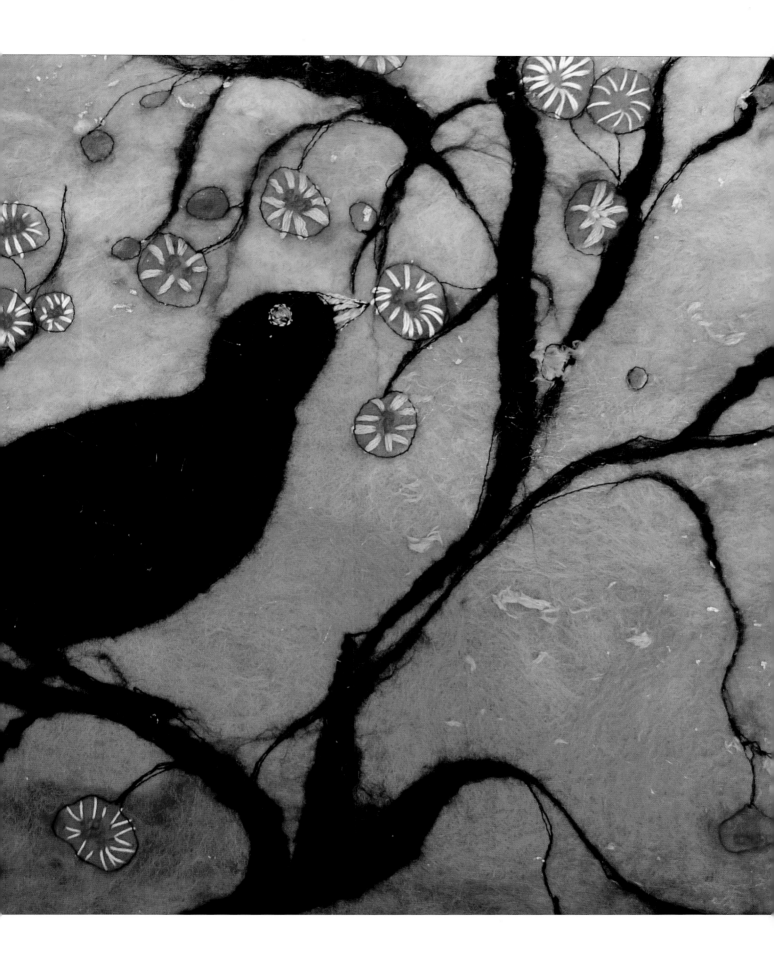

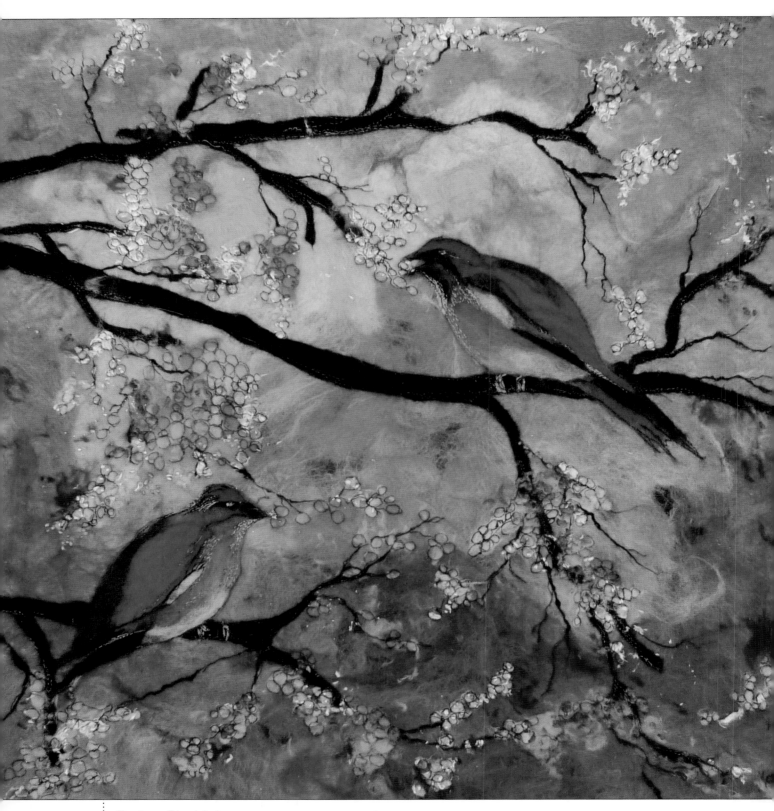

Eastern Bluebirds

68 x 68cm (26³/₄ x 26³/₄in)

Many a long hour was spent on this piece. I was inspired by Japanese paintings of cherry blossom and set out to fabricate a similar look. A large part of the time was spent on the blossom and berries as I worked into these with predominantly machine stitching to create finely drawn lines.

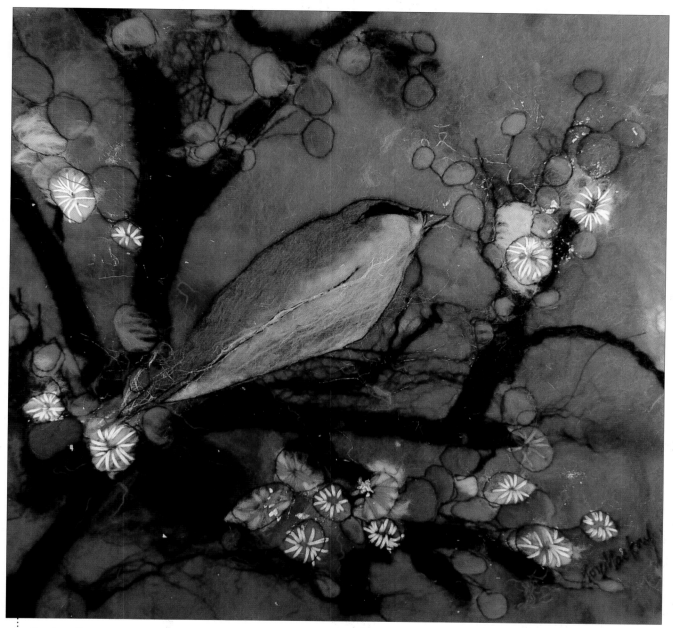

Spring Song

18 x 18cm (7 x 7in)

This was a relatively small piece in which I rolled lots of pink balls of merino to give shape to the berries. I chose to give the berries greater definition as they were overly subtle and fading into the background; by the use of fine outline stitches they have become an integral part of the work.

Project: Bird with Berries

Working with animals can always be tricky and birds are no exception. I would strongly advise for this project that you work directly from photographs or detailed drawings where there is no chance of the bird flying away! Be loose with your background – even one simple flat colour can work effectively against the exquisite markings of a bird.

In this project I worked from an image a photographer friend had taken. I modified the background colour to make the bird stand out more, which worked well.

Layering the fibres and composing the picture

1 Choose the colours and fibres for your project. I have used a range of light blues, silvery greens, pinks, maroon, brown and yellow – about ten different colours in total – and some blue and light green Angelina.

2 Lay out a square base using undyed fleece, about 30 x 30cm (12 x 12in). Card together various shades of blue to create a mottled effect, then lay this on to the base to create the background.

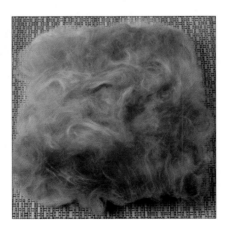

3 Lay a slightly darker mix of blue fleece around the top and bottom and down the right-hand side.

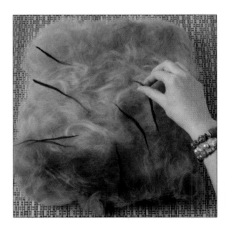

4 Take some small strips of brown fleece and twist them together to form fine branches of varying width. Lay them on the background.

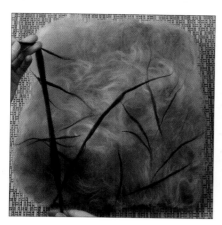

5 Make the thicker branches in the same way but using larger pieces of fleece and place these on the background.

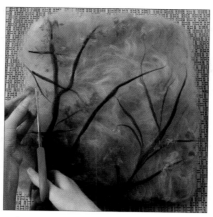

6 Make some of the blossom and berries by cutting small pieces from two shades of pink fleece and scatter them along the main branches.

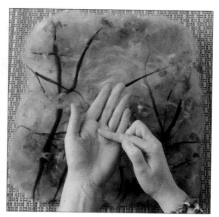

7 Make rolled versions for the more prominent berries using a mix of two pale shades of pink. Position these on the background.

Tip

By creating the general impression of berries in the background and overlaying them with a few distinct berry shapes in the foreground, you give your picture a sense of depth.

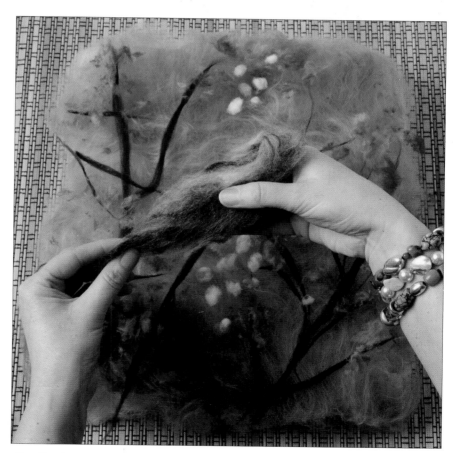

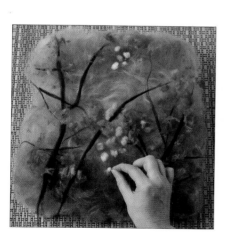

8 Create some lighter coloured berries using a mix of pink and white fleece.

9 For the bird, take some black and white fleece carded together to make a mottled grey colour and tease out the fibres so that they all lie in the same direction. Gently mould the fleece into the shape of a bird.

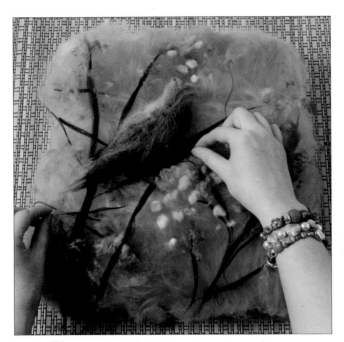

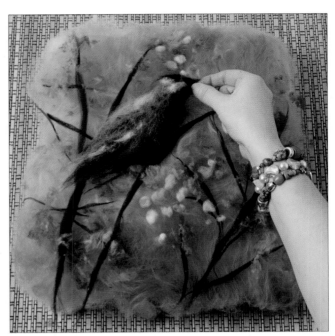

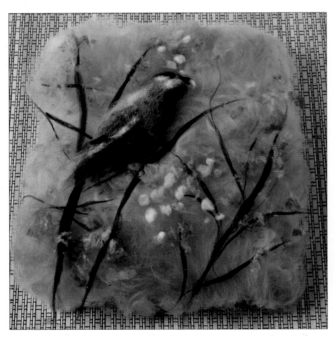

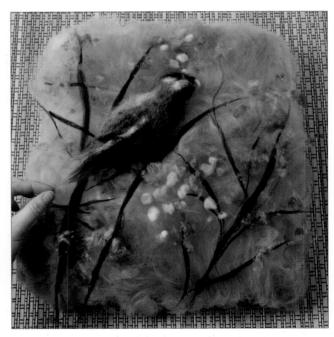

10 Position the bird on the background. Make two legs by twisting together small lengths of black fleece and place them under the bird.

11 Add detail by laying a small piece of brown fleece on top of the bird's head and another piece under the lower edge of its wing. Place small patches of white on the bird's face and wing and black around the throat and eye, then finally cut a tiny piece of black fleece and lay it on the bird's beak.

12 Roll up a pink and white berry and place it in the bird's beak.

13 Put a touch of bright yellow into the tail, laying it partly under the bird to blend it in.

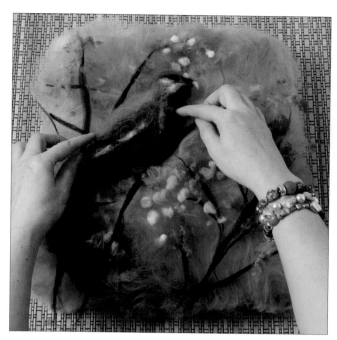

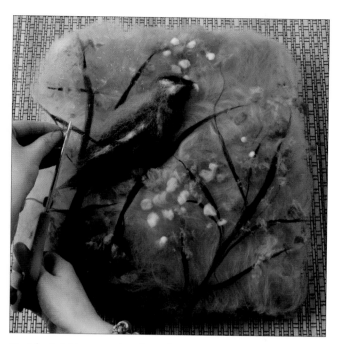

14 Continue to add in small amounts of the grey carded fleece to improve the bird's shape where necessary.

15 Add in more berries where needed and sprinkle some cuttings of blue and light green Angelina over parts of the background.

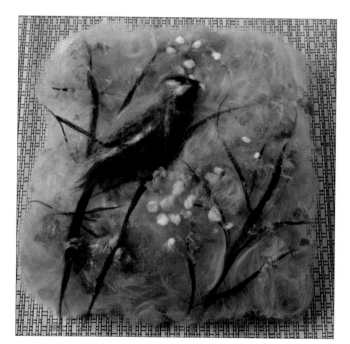

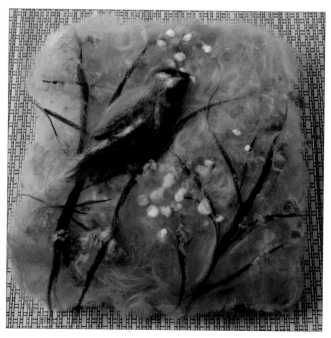

16 To vary the background a little and add a sense of movement, lay some wisps of silvery green fleece here and there.

17 Darken the lower part of the picture by adding in some wisps of darker blue. The picture is now ready for felting. Felt the picture following the instructions on pages 42–44.

Refining the detail using needle felting

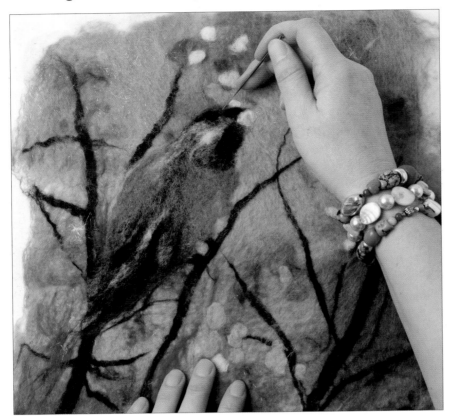

18 Use needle felting to define the shape of the bird, paying particular attention to the beak and the area around the eye. Redefine the shape of the berry in the bird's mouth, making it rounder in shape.

Tip

If at any time you aren't happy with a piece of needle felting, simply peel it off and start again.

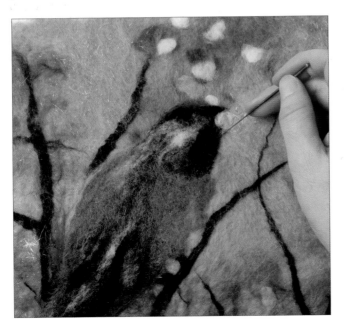

19 Use the needle to scratch the felt and tease out the fibres around the bird's throat and breast. Use needle felting to reshape them and make a sharp, well-defined edge.

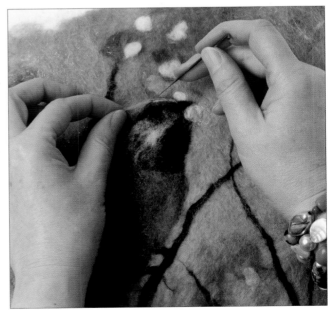

20 Take a small piece of white fleece, twist it and needle felt it on to the top of the bird's head. Add a little more white around the bird's neck too.

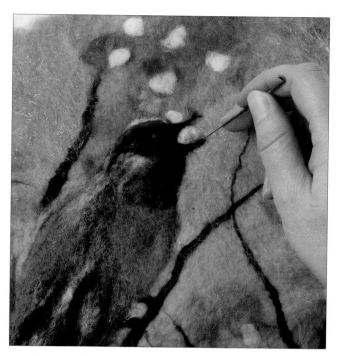

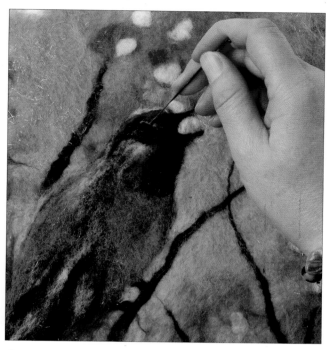

21 Redefine the beak by adding in two more pieces of black fleece – one for the upper and one for the lower part.

22 For the eye, use needle felting to add in a tiny piece of white fleece.

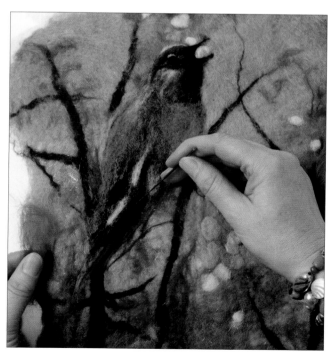

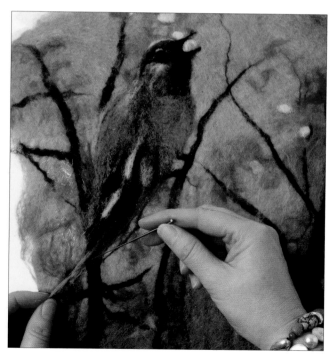

23 Add in a little more white fleece along the edge of the wing, and accentuate the brown patch using a mixture of brown and maroon.

24 Take a small piece of bright yellow fleece and needle felt it into the tip of the tail.

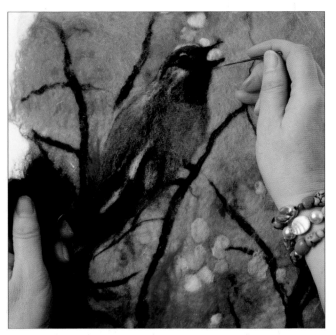

25 Intensify the colour of the bird's throat by adding in a little more black.

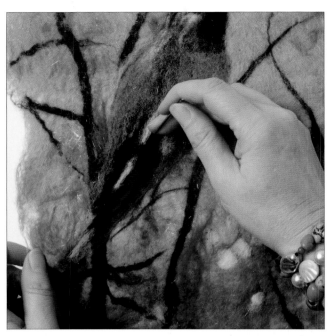

26 Strengthen the black areas under the wings in the same way.

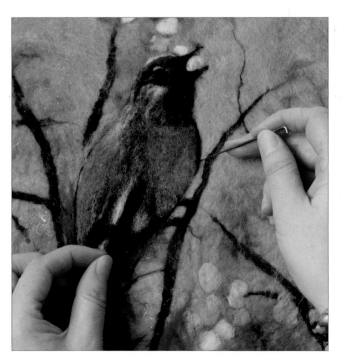

27 Define the edge of the wing by running a very thin line of black fleece around it, and strengthen the outline of the bird's body in the same way.

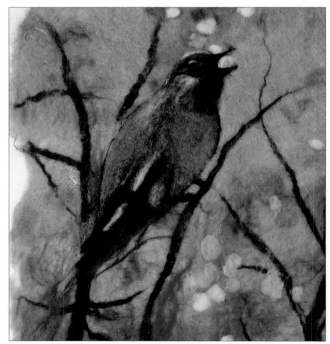

28 Once you are happy with the shape of the bird and the detailing, add the iron-on adhesive backing as described on page 46 and your picture is ready for stitching.

Machine stitching

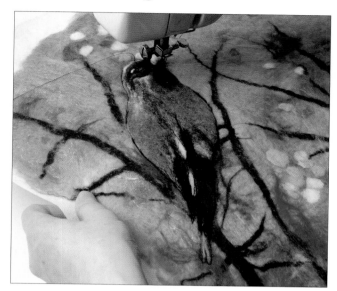

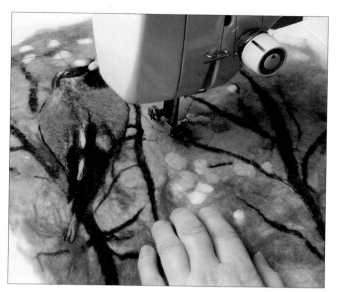

29 Thread the top of the machine and the bobbin with black thread and stitch around the outline of the bird to define its shape. Work carefully down the legs and around the claws. Place some lines of stitching over the dark patches under the wings to strengthen the shadows, then work carefully around the eye and over the dark markings on the head.

30 Follow the main branches with more dark stitching to emphasise their form and bring them further forward in the picture.

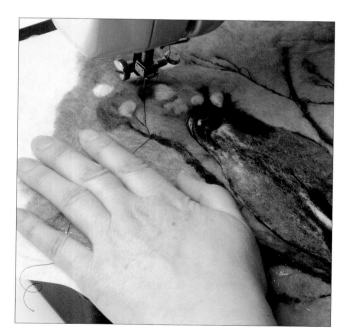

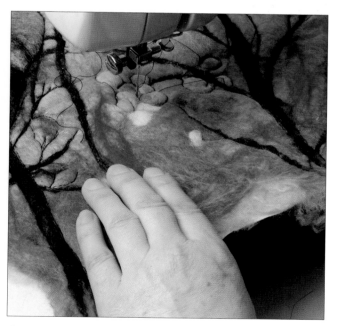

31 Create fine stalks connecting the berries to the main branches using lines of stitching.

32 Outline some of the main berries to strengthen their shape and bring them into the foreground. The overall effect will be to give the picture depth.

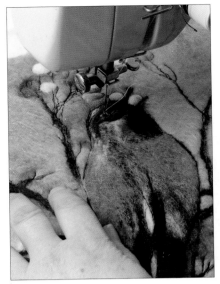

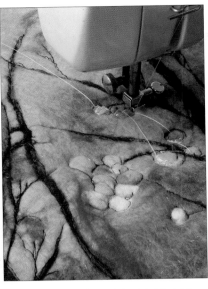

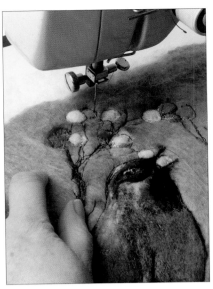

33 Change to a cream thread on the machine and in the bobbin and outline the bird's eye.

34 Add a tiny white highlight to some of the main berries.

35 Rethread the top of the machine and the bobbin with deep pink thread and add a small amount of pink stitching to some of the berries.

Hand stitching

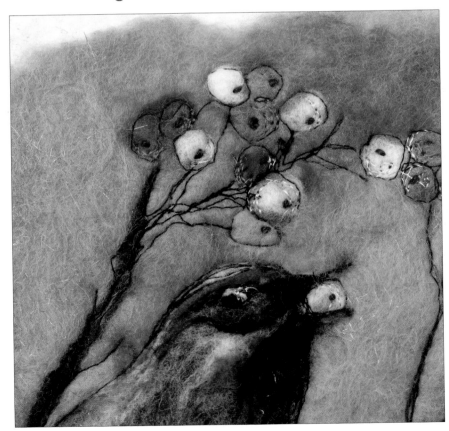

36 Using six-stranded cotton, place a tiny black dot on each of the main berries, worked as a single tiny stitch. Also place a single black dot in the eye. This will really bring your bird to life.

Finishing

Finish your picture following the guidance on page 51.

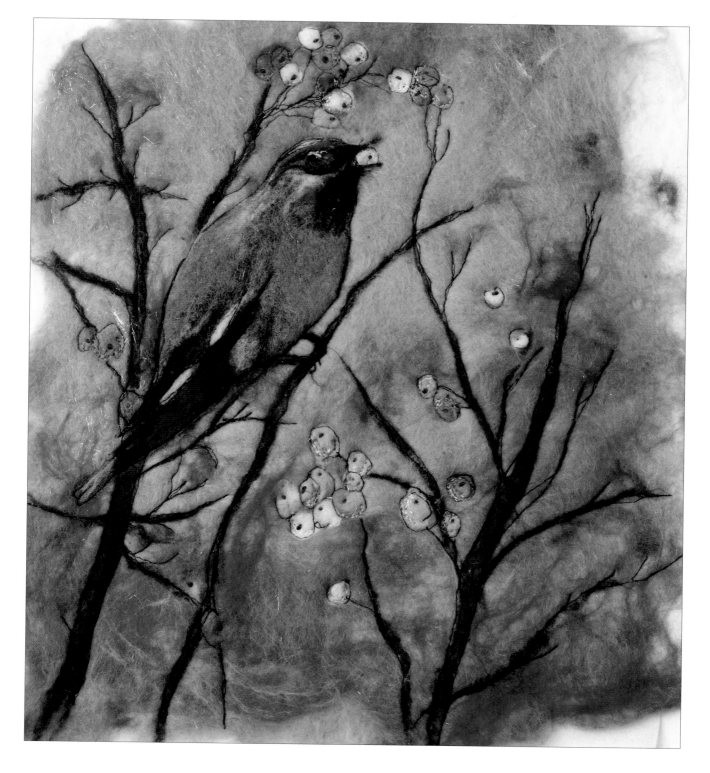

FLOWERS

What I particularly enjoy about working on a flower project is that you undoubtedly get a better result by working from the real thing. This means surrounding yourself with fresh, fragrant flowers that you can then study from every conceivable angle. Interesting works can be achieved by concentrating solely on small sections of a flower – a petal or perhaps the stamen – to re-create the incredible patterns within that usually go unnoticed.

92

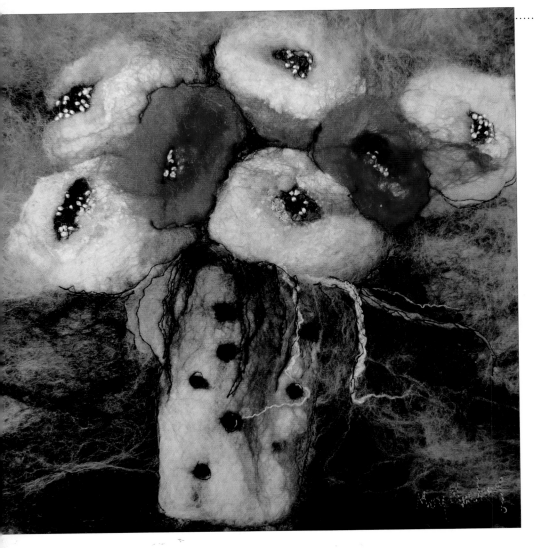

The Wee Spotty Vase (left)
26 x 26cm (10¼ x 10¼in)

Adding thin layers of black to the background over brighter colours gave a strong foundation to this picture. The white of the vase and the pale flowers against the black make for a dramatic statement. Working from papery white, pale pink and deep red anemones, I chose not to add too much detail to the flowerheads themselves as I liked the effect that the combination of various fibres achieved naturally. Stitched dots gave the impression of the inner stamen without being overly fussy. Stitched lines were essential to define the lines of the leaves. I decided to add the dots on the vase at the end as I felt the plain, white vase needed enhancing.

Daffodils for Linda (right)
38 x 38cm (15 x 15in)

Working directly from a vase of various types of daffodils provided me with an interesting array of shades and structures. I actually formed some of the daffodil heads in my hand, sculpting them as I would a clay flower, bending the petals this way and that until I found something that resembled the real thing and that I was happy with. Only at that point did I place the flowerhead on to the composition. Working like this can give a very realistic movement to your flowers.

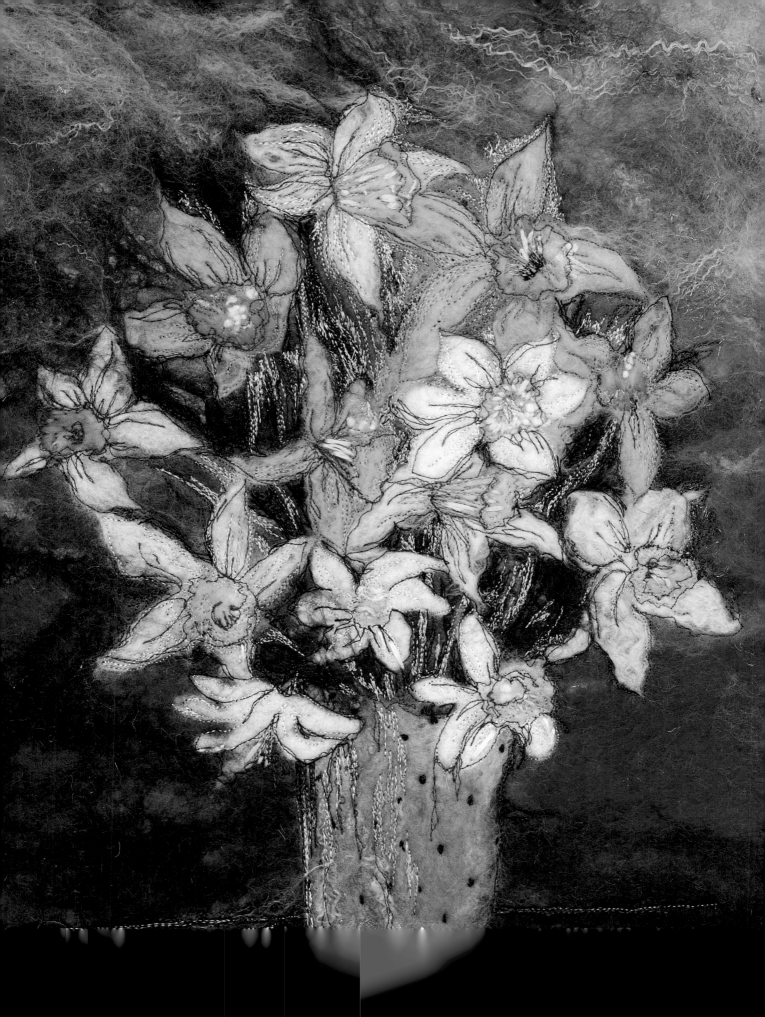

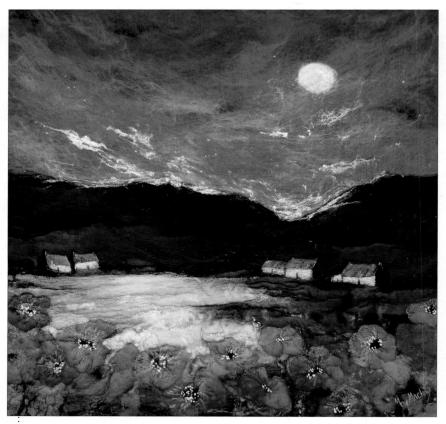

By the Light of the Heather Moon
60 x 60cm (23 1/2 x 23 1/2in)

In this landscape, and the one on the facing page, flowers form an important part of the composition, creating a strong sense of depth and perspective. By adding small fibres of white silk within the sky, tucked just behind the faraway hills, I have introduced highlights that help to evoke the feeling of moonlight illuminating the landscape.

Poppy Shore, Starry Sky
58 x 58cm (22 3/4 x 22 3/4in)

In this landscape I wanted to capture the stormy, moonlit sky, so I added small pieces of white silk noil while carding together the blues and turquoise of the sky. I loved how the distant hills were dark and sleepy yet the shoreline and poppies remained vibrant. I gave more attention to fine detail in the foreground, creating a good sense of depth to the piece.

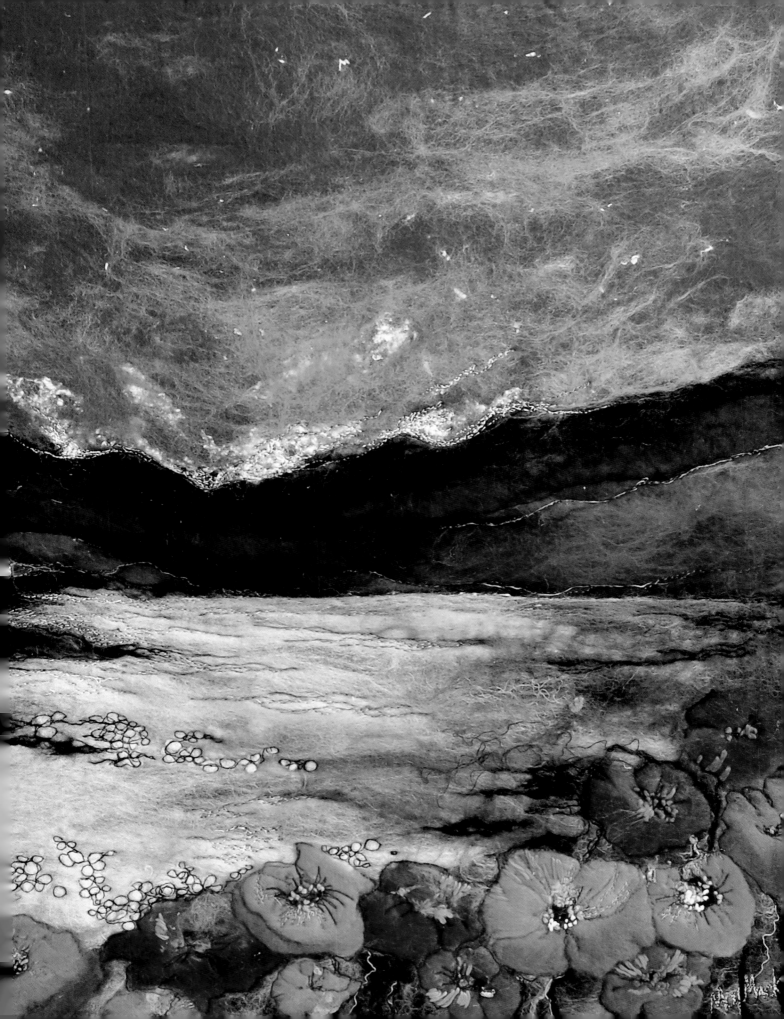

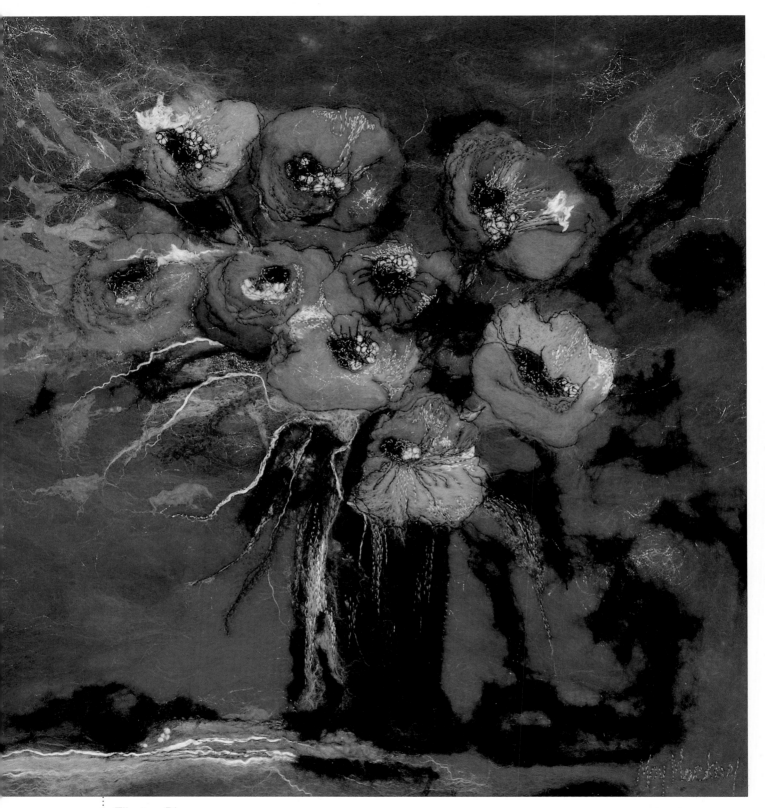

Tibetan Blues

40 x 40cm (15¾ x 15¾in)

It is always a pleasure to work from my favourite flower. I wanted to make this a very blue piece but did add small amounts of pinks and blacks to give additional depth.

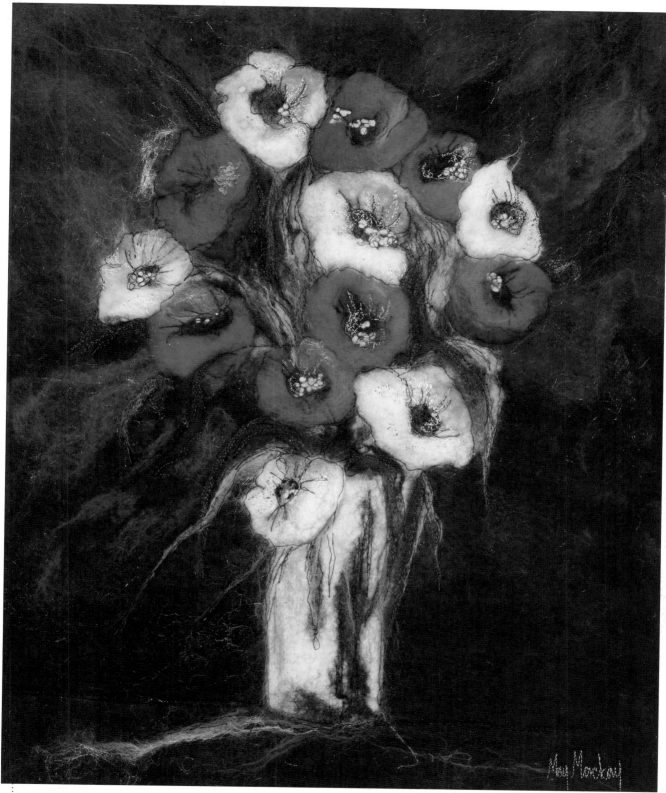

Reds and Whites

42 x 52cm (16½ x 20½in)

By mixing mainly black merino with a hint of purple and blue, I established a velvety background on which to work. In contrast, the use of white and bright red flowers against the dark gives an atmospheric edge to this piece.

Martha's Vase

52 x 52cm (20½ x 20½in)

What's not to love about poppies? An inspirational flower for most artists. I love the form, the detail within, not to mention the empowering reds that seem to say so much. This medium seemed to be made for the re-creation of poppies! In this piece I wanted to create something beautiful yet peaceful as a personal memory of my old friend, Martha. The background was created using a simple blend of blues placed relatively randomly. The boldness of the design on the vase created an interesting contrast with the naturalness of the poppies. By using a variety of red shades, a more three-dimensional feel is given to the flowers. Highlights of orange and pink stitches gave further interest to the flowers, with wool nepps added for the centre detail.

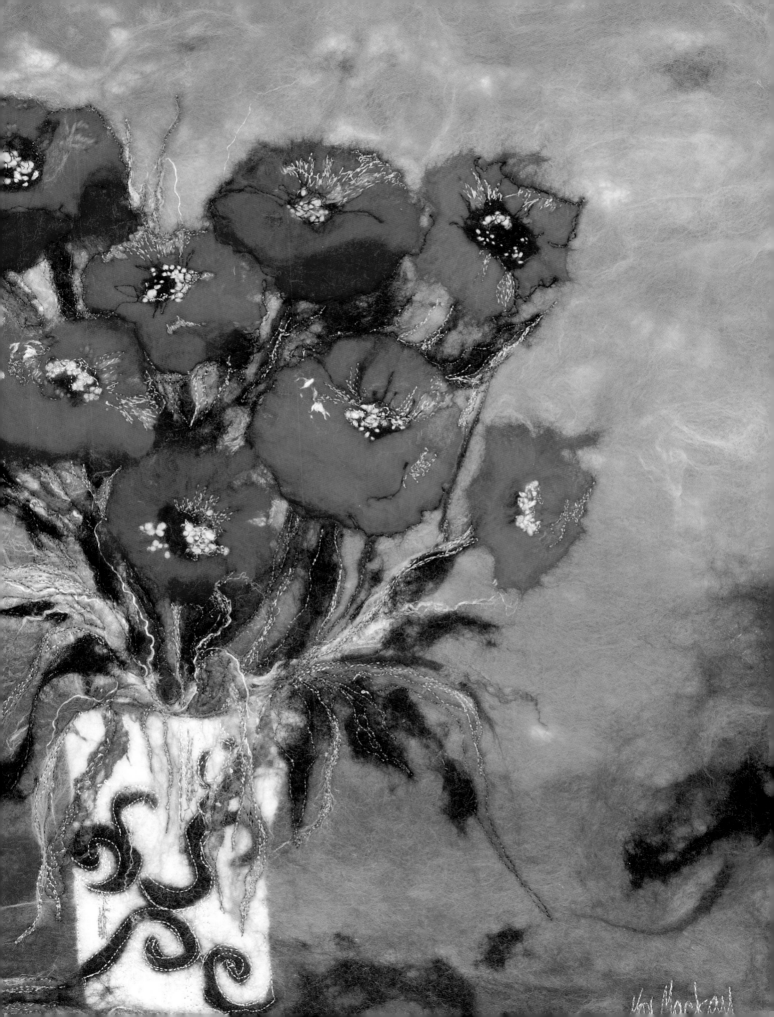

PROJECT: ANEMONES

When it come to flowers, wherever possible work from the real thing. Whilst images of flowers can be stunning, none do the beauty of a real flower justice. To be able to see the form of a flower is paramount in creating something special. Get to know your subject, hold it, study it, smell and enjoy it. In doing this, your work will take on an energetic quality, which would be sorely lacking if working from a flat image.

Anemones are beautiful subjects for a felt painting. The rich, jewel-like colours of the petals contrasting with the strong, dark centres, and the simple form of the flowers themselves, make them perfectly suited to being re-created in felt.

Layering the fibres and composing the picture

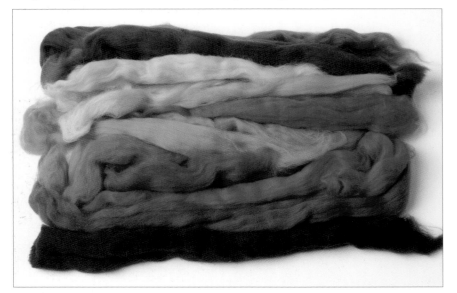

I Begin by selecting the colours and fibres for your picture. For this project I have chosen a good range of rich, jewel-like colours – dark and mid red, greens (including a green rainbow-mix fleece), blues, purples, black and some lighter tones. I have used about fifteen different colours in total. I have also used pink Angelina, white Mulberry silk and white wool nepps.

2 Lay out the white base using undyed fleece in portrait format, about 25 x 30cm (10 x 12in). For the background, make two quantities of carded fleece – one with black, royal blue and light turquoise and one with black and royal blue only. Mix the two carded fleeces together by carding to make a uniformly mottled background and lay them over the base.

3 Add a little more of the blue and black fleece to the lower half of the picture to distinguish it from the top half.

4 Make a paler mix of blue, black and turquoise fleece and lay it in the top left-hand corner of the picture.

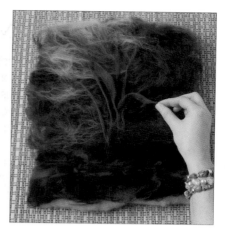

5 Start to lay on the stems and leaves. Take short lengths of dark green fleece and twist them to form stems of various thicknesses. Lay them on to the background. Make leaves by twisting short lengths of fleece at the top and bottom only and teasing out the middle part.

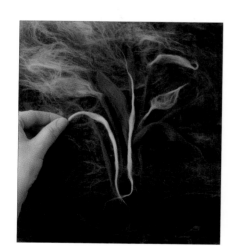

6 Build up layers of stems and leaves using progressively lighter shades of green. Finish with some tall, slender pale green leaves, formed from long, thin lengths of fleece twisted together at each end. Lay them on the background and curve them over at the tip.

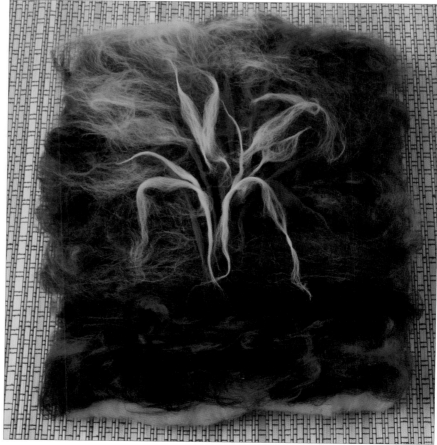

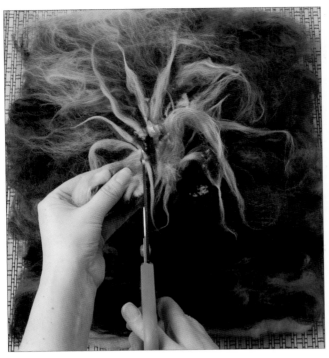

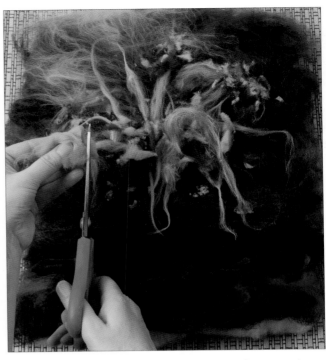

7 Make some more leaves from green rainbow-mix fleece and add these in, then sprinkle on some trimmings of dark, light and rainbow-mix green fleece.

8 Snip off some pieces of yellow-green fleece and add these too.

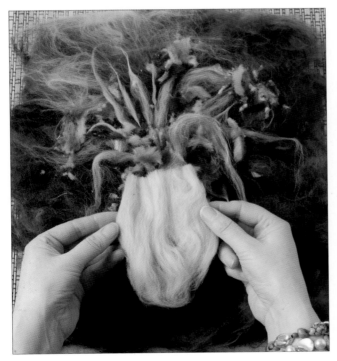

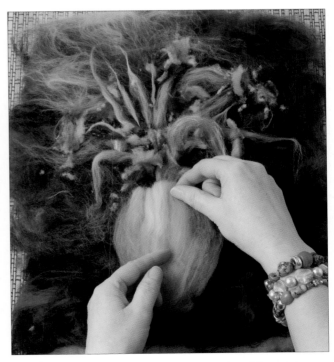

9 For the vase, cut a length of light turquoise fleece, flatten it out and cut it into a vase shape using scissors. Position the vase on the picture.

10 Add some shadows, mainly at the sides of the vase, using long wisps of fleece in a slightly darker shade.

11 Reposition some of the leaves so they lay over the vase.

12 Place a few strips of black fleece around the edges of the vase to help define its shape, and add some tiny pieces of black to the vase itself to give it depth.

13 Cut a piece of dark red fleece and open it up to form the shape of a flowerhead.

14 Vary the shapes of the flowerheads depending on their positions in the vase and place them on the background.

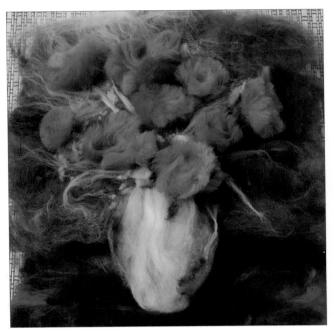

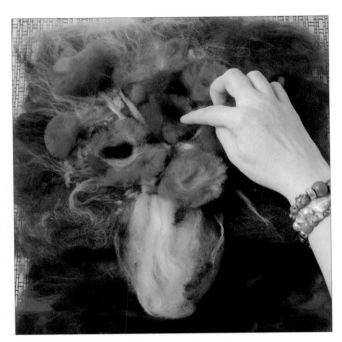

15 Make the remaining flowerheads using different shades of red; make some using two shades of dark pink mixed together by hand. Vary the angles of the blooms and their sizes (by using more or less fleece) to create a realistic arrangement.

16 Where the centres of the flowers are visible, take tiny pieces of fleece in a slightly lighter shade and place them in the centre of each flower, then place a small ball of black fleece in the middle of that.

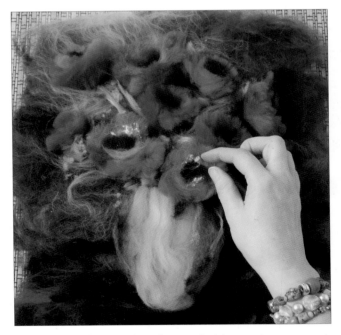

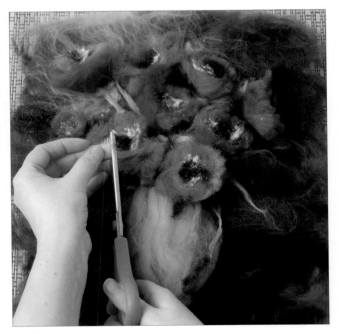

17 Cut off some tiny pieces of white wool nepps and place them around some of the flower centres to create highlights.

18 Trim off some tiny pieces of pink Angelina and sprinkle them in the middles of the flowers to add sparkle.

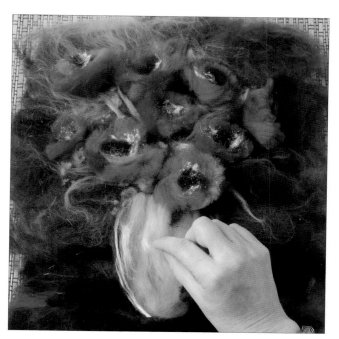

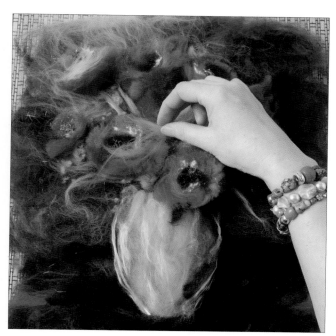

19 Create a highlight on the left-hand side of the vase using wisps of white Mulberry silk.

20 Also add highlights in the form of wisps of light pink fleece to some of the flowers.

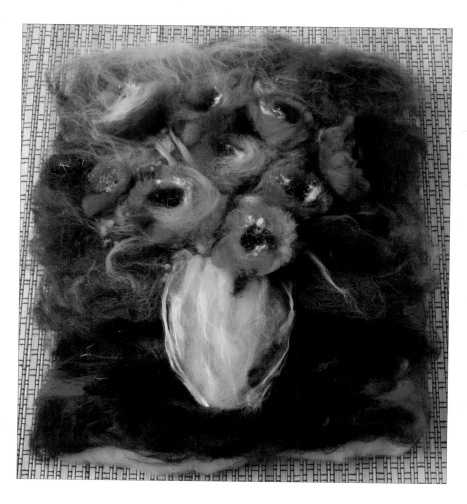

21 Your picture is now ready for felting following the instructions on pages 42–44.

Refining the detail using needle felting

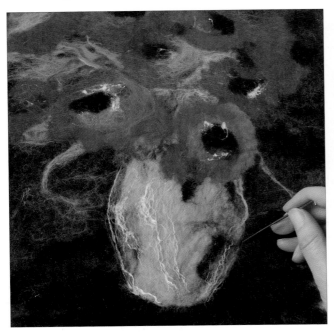

22 Use needle felting to redefine the shape of the vase.

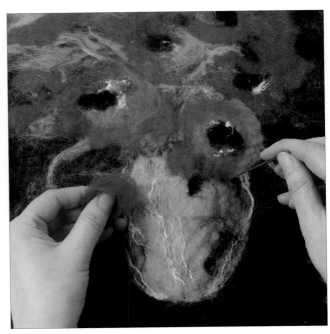

23 Take some small, fine pieces of dark blue fleece and needle felt them in place down the right-hand side of the vase to create shadows.

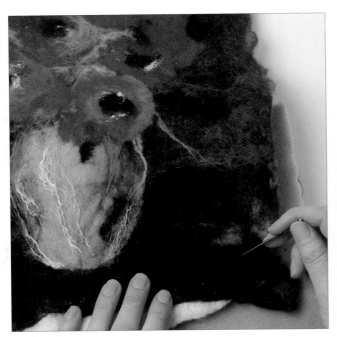

24 Fill any gaps in the background with patches of blue and black fleece.

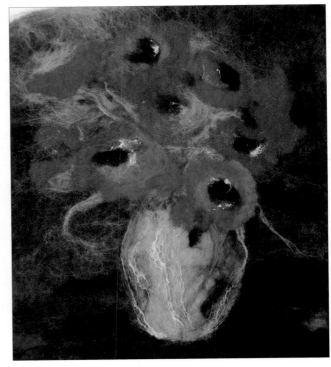

25 Check you are happy with your picture, then you are ready to start stitching. Remember to attach the iron-on adhesive backing first, as described on page 46.

Machine stitching

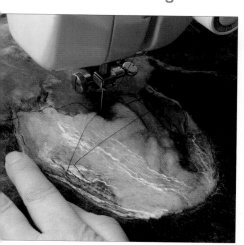

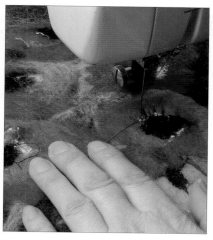

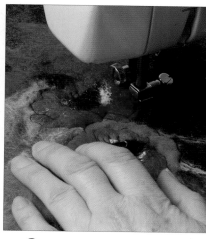

26 Using black thread on the top of your machine and in the bobbin, stitch around the outside of the vase to define its shape. Also outline each of the petals and leaves that are overlapping the vase, taking the threads across as you work and snipping them off at the end.

27 Lay some lines of stitching into the shadows on the vase to strengthen them, and put some stitched lines in the centres of some of the flowers for the stamens.

28 Outline more of the flowers and leaves to emphasise them and bring them further into the foreground. The rest of the flowers will recede, adding depth to the picture.

107

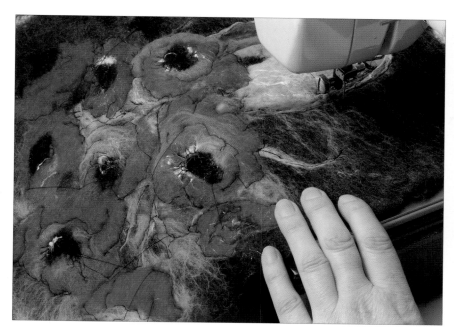

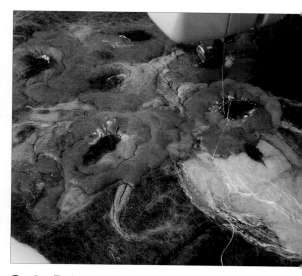

29 Put in a line of stitching to define the edge of the surface on which the vase is standing.

30 Rethread the machine and the bobbin with cream thread. Brighten the highlights by laying some lines of stitching down the left-hand side of the vase and along the white patches. Put more stamens in the centres of the flowers to bring them further forward.

Tip

You don't need to go around the whole of a shape; an incomplete outline defines the shape just as well and creates a more interesting effect.

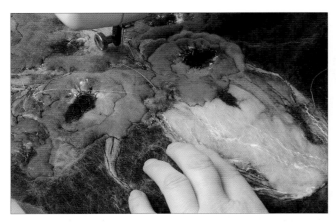

31 Change to light green thread on the top of the machine and in the bobbin, and add highlights to some of the green leaves.

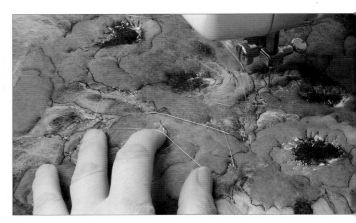

32 Using deep pink thread on the top of the machine and in the bobbin, add some pink stitching to the edges of some of the pink flower petals.

Hand stitching

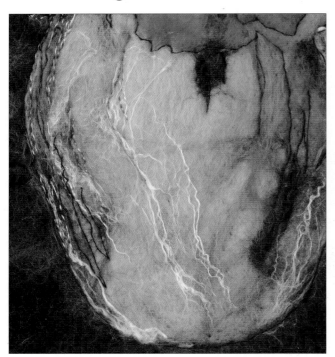

33 Using doubled six-stranded cotton thread in white, run several lines of straight stitching down the left-hand side of the vase to lighten it. Follow the shape of the vase and work with the patterns created by the fleece.

34 Work uneven straight stitches radiating out from the centres of the flowers and around the edges of the petals to give the flowers form. Use colours that are similar to those of the petals. Place some raised white highlights in the centres of the flowers, each worked by overlaying several stitches. Use six-stranded cotton for the smaller dots and doubled six-stranded cotton for the larger ones. Add highlights to the leaves using straight stitches worked in pale green thread.

Finishing

Finish your picture following the guidance on page 51.

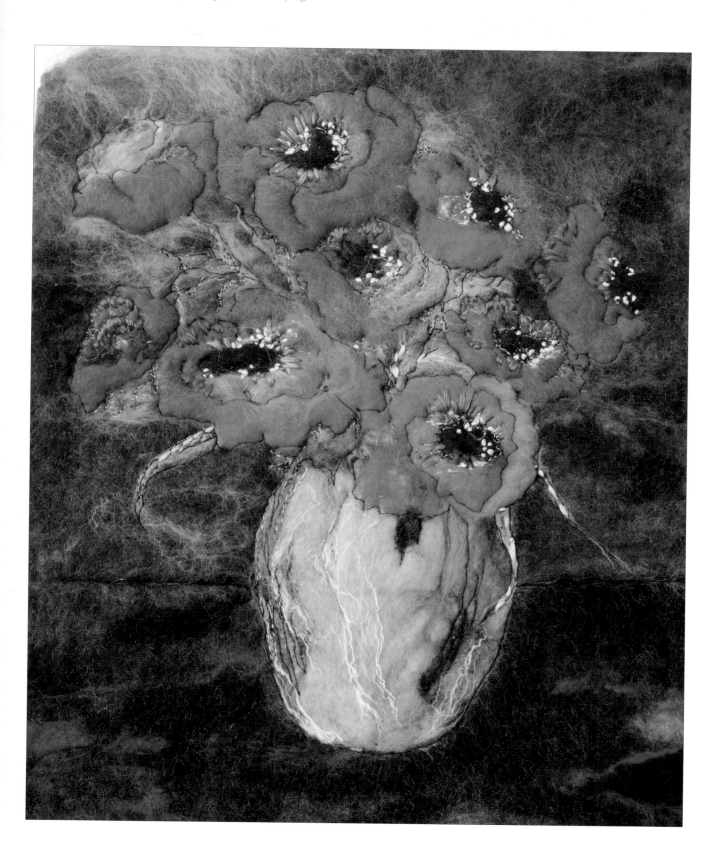

STILL LIFE

While landscape felting is my main subject, I like to experiment with different subjects from time to time. Among them have been animals, primarily sheep, fruit, shoes (because I can never have enough shoes!), and my scrummiest of all: cakes. Again, with still-life projects, working from the real thing is by far the best option. Set up a still life using some interesting fabrics as backdrops, then carefully position a few items in front of it that inspire you. The beauty of the cake project is that you are allowed to eat the cake at the end!

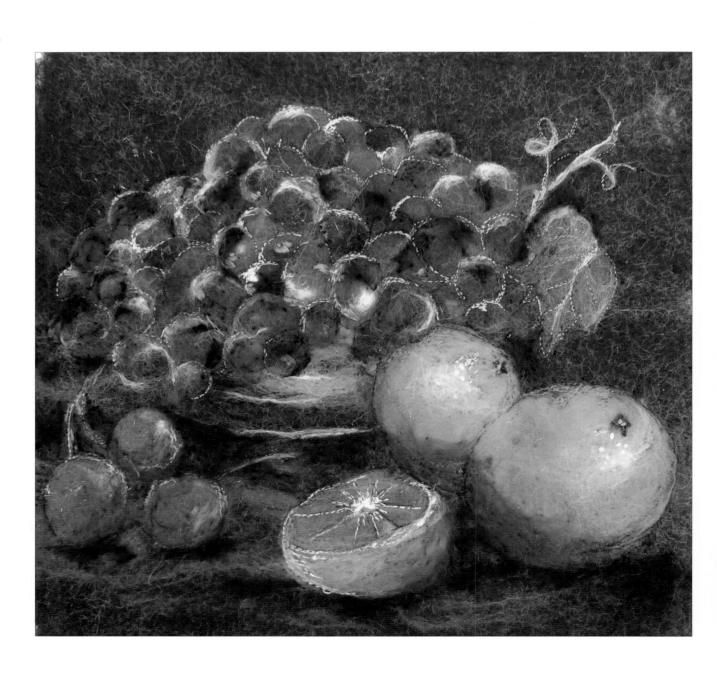

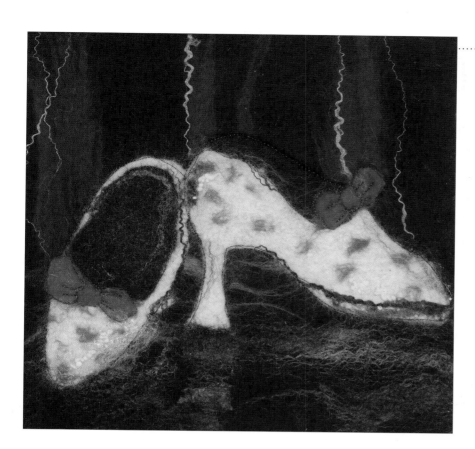

The Party Shoes

30 x 30cm (11 3/4 x 11 3/4in)

I wanted to keep this composition simple. The shoes were the star here, which have a deliberately simplistic, almost naïve, quality. I added a few lines from the background fabric to add interest and structure.

Flamenco Time (right)

30 x 30cm (11 3/4 x 11 3/4in)

Another minimal composition. Some darker shades of brown were added to create shadows on the surface on which the shoes stand.

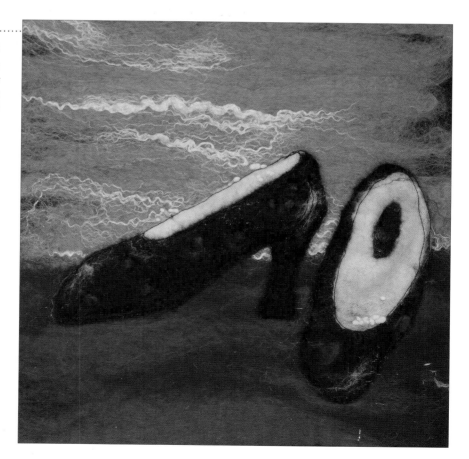

Fruit Study (left)

30 x 30cm (11 3/4 x 11 3/4in)

My intention here was to re-create the feel of an old oil painting. I used a felting needle to add much of the highlights to the fruit, combined with areas of machine stitching to give a sense of realism to the composition.

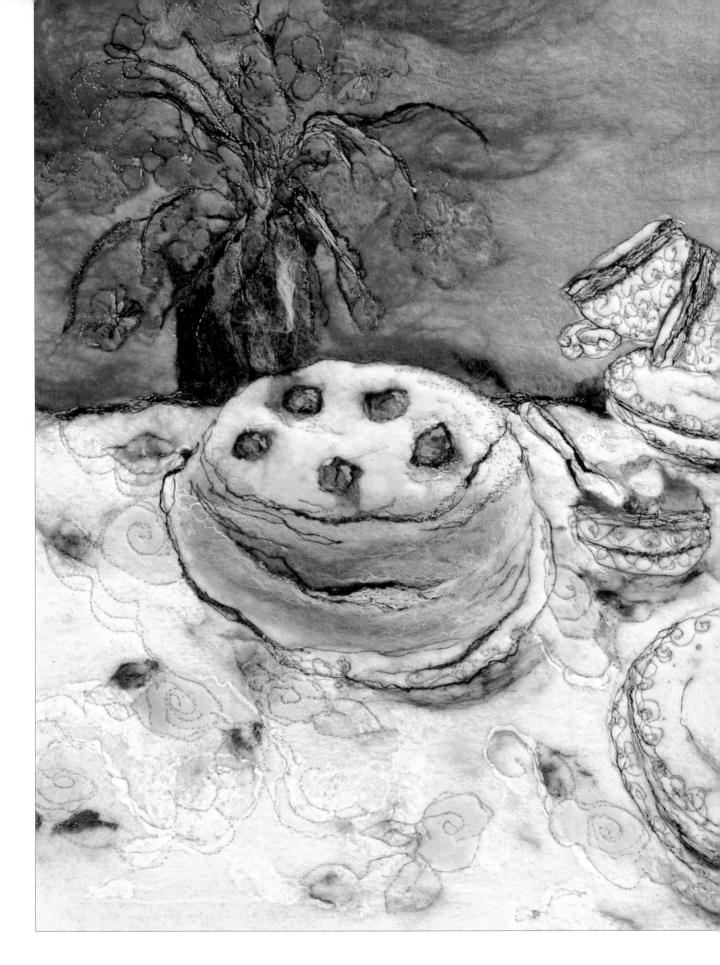

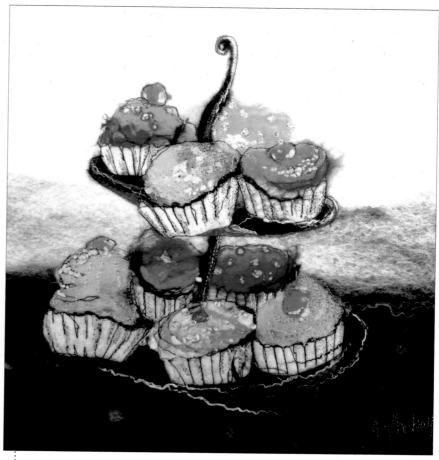

Cupcakes (above)

38 x 48cm (15 x 19in)

Cupcakes are great fun to work on. I especially enjoy the finishing touches where I can decorate them with all sort of marks and stitches — almost as much fun as decorating the real thing! Like the tea party on the facing page, working with fleece has resulted in a gorgeously haphazard pile of scrumptious cakes that look good enough to eat. Here, I wanted the cupcakes to be the main focus so I decided to contrast their vibrancy and detail against the starkness of a black and white background. To define the black cake stand, I outlined it with lighter coloured stitch marks. On the cakes, I twisted two shades of the same colour together to look like real icing. Be as creative when embellishing your felt cakes as you would be when decorating the real thing!

Afternoon Tea (left)

45 x 45cm (17³/4 x 17³/4in)

This is a detailed section of a larger piece of work. A great amount of detail was added to this piece in the final stages in the way of machine stitching. I used metallic threads to enhance the patterns on the china crockery. Avoiding straight lines, I worked with the fleece to position the various elements, resulting in a slightly wobbly, distorted composition that would be perfectly at home in Wonderland!

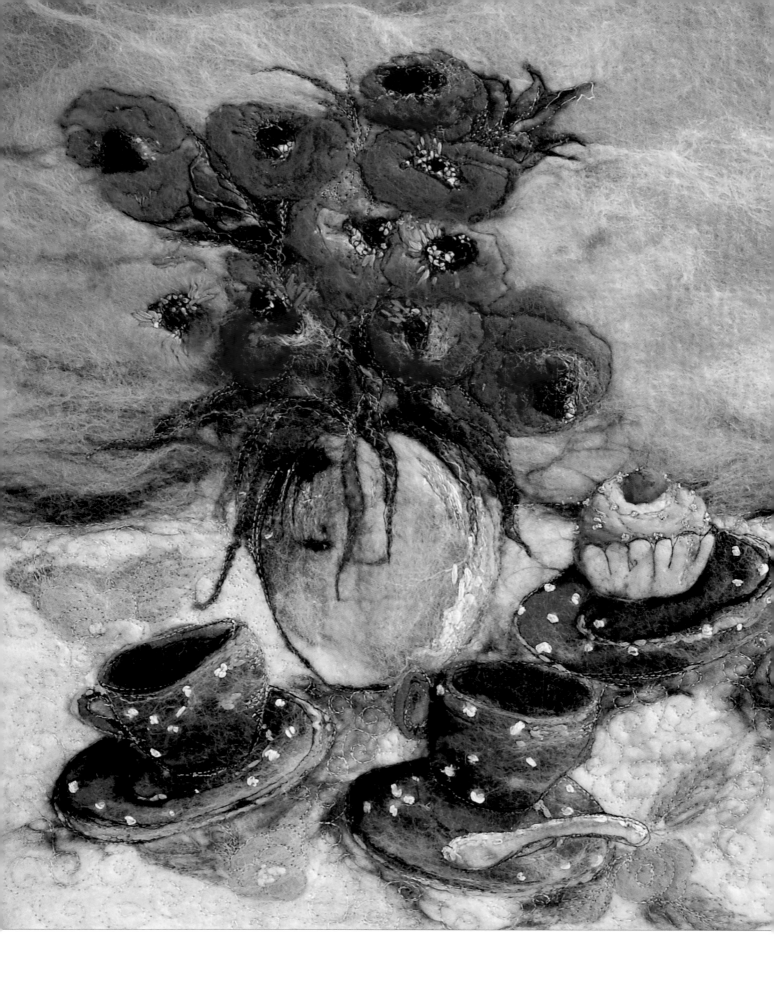

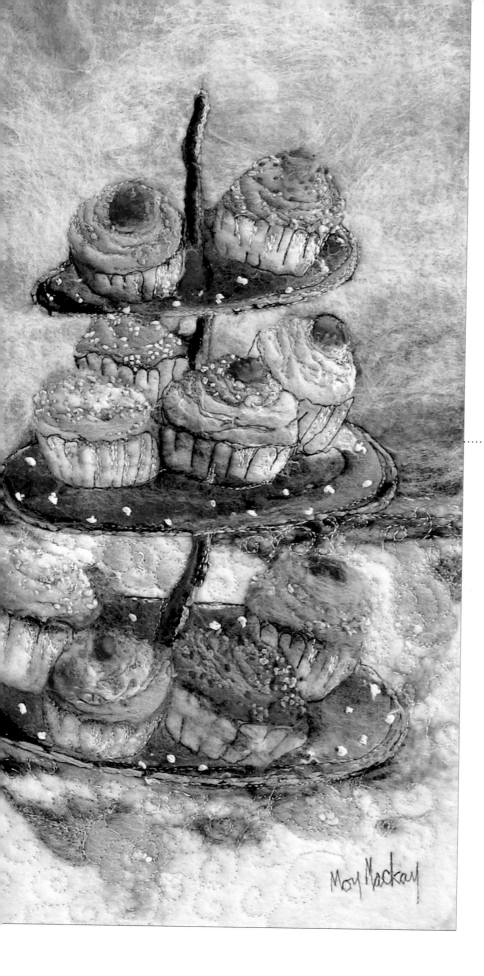

Dotty Rose Cupcakes

62 x 45cm (24½ x 17¾in)

This is possibly one of my all-time favourite pieces. Prior to setting up the still life, I baked the cakes, picked the flowers, laid my favourite lacy tablecloth and selected my favourite spotty cups. The rest seemed easy as I had already set up the composition to just how I wanted the piece to look. Lots of embroidery was added in the latter stages to define specific areas and to add decorative detail.

Project: Tea and Cake

Set up a small still life with an interesting cup, plate or even a teapot. Patterned pieces are good as these give interesting sections to work from and can be developed with stitches at the end. Treat yourself to a nice cake for later and pop that in too. Play with the set up until you are happy with how it looks, and you are ready to begin.

Here I have set the highly decorative, vintage crockery against a simple backdrop of white and grey; the polka dots help to give the piece a more contemporary feel. I have really gone to town on the cake, adding layer upon layer of swirling icing, sugar, and hundreds and thousands, and topping the whole lot off with a delicious cherry!

Layering the fibres and composing the picture

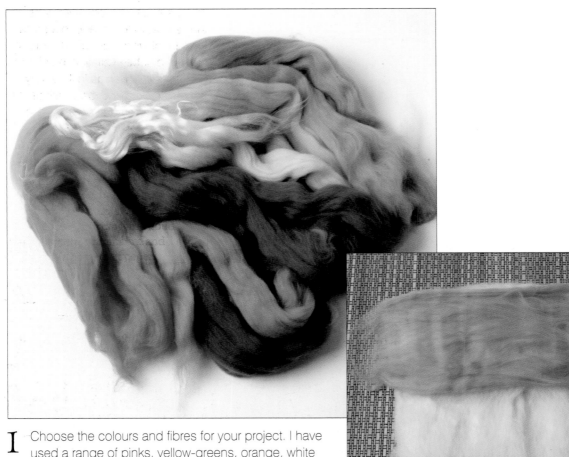

I Choose the colours and fibres for your project. I have used a range of pinks, yellow-greens, orange, white and grey-blues – about fourteen different colours in total, as well as some light green and yellow Angelina, white silk noil, white wool nepps, pink and white Mulberry silks and tiny pieces of gold leaf.

2 Lay out a square base using undyed fleece, about 30 x 30cm (12 x 12in). Tease out a length of blue-grey fleece so that it is flat and even and lay it over the top half of the picture.

3 Card together the same colour with a darker tone and lay this over the first layer.

4 Roll about eight small balls of white fleece in your hands.

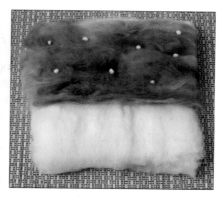

5 Place them randomly over the grey background.

6 Card together some white and pale green fleece then, when they are well mixed, add in a small amount of white silk noil. The green creates a subtle variation in colour and the silk noil adds texture. Lay the fleece on to the lower half of the picture in horizontal strips. Add in more silk noil if necessary.

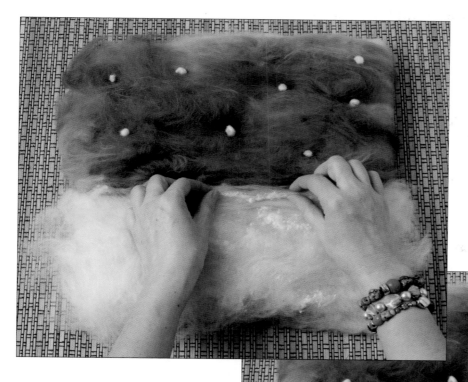

7 Mix a little black and white fleece together and lay it in a fine diagonal strip across the tablecloth. This will be the shadow underneath the plate and the saucer.

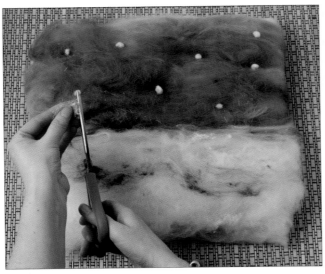

8 Cut off some tiny pieces of light green Angelina and sprinkle them randomly over the background to create a subtle, sparkly effect.

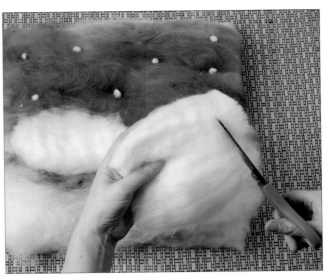

9 For the plate and the saucer, tease out two wads of white fleece into oval, flat shapes and place them on the background, overlapping them slightly.

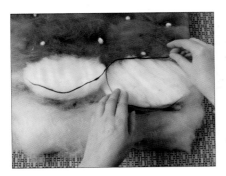

10 Cut small lengths of black Mulberry silk to edge the plate and the saucer. Twist the silk in your fingers to make long, thin strands and lay them on the picture.

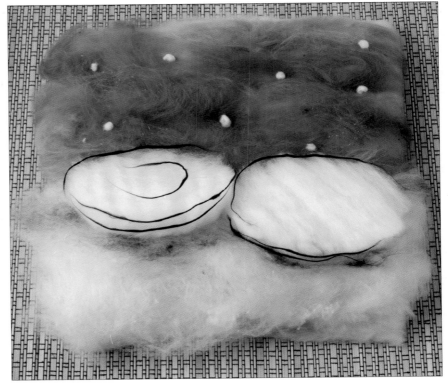

11 Roughly outline the saucer and plate, and define the middle of the saucer. Notice I have left a small gap, representing a highlight, on the right-hand side of each one.

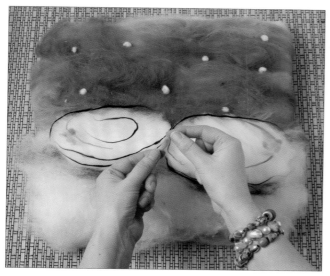

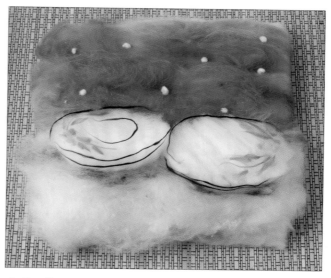

12 For the roses, use either small balls of pink fleece, teased out and placed thinly on the picture, or cut shapes out of a piece of fine, pink fleece. For the stems, use small, twisted lengths of green fleece.

13 Form the leaves by taking short lengths of two different greens and twisting them together at the top and the bottom. Lay the leaves on to the stems.

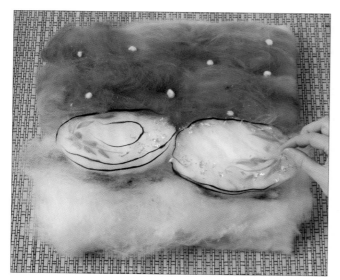

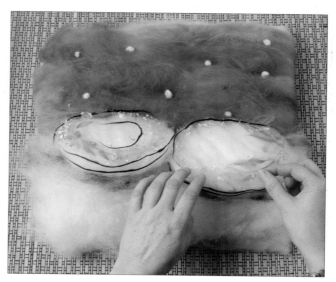

14 Sprinkle on some tiny pieces of gold leaf to decorate the edges of the plate and saucer. Some will fall off after felting, so add slightly more than you feel you need.

15 Lay extremely fine wisps of orange fleece over the gold leaf. This will add a subtle hint of colour and help hold in the gold leaf after felting.

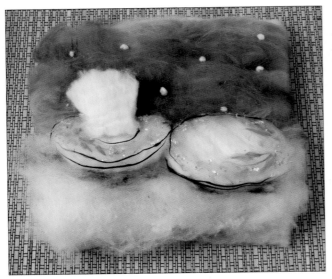

16 Cut the cup shape from a piece of flat, white fleece (as you did for the plate and saucer). Position the cup on the background.

17 Form the handle from a thin, twisted length of white fleece. Lay a fine length of black fleece around the rim, body and handle of the cup to define its shape.

Tip

Don't try to make perfect shapes – the beauty of working with felt is that you are creating an impression, not re-creating reality. Be as imaginiative as you like!

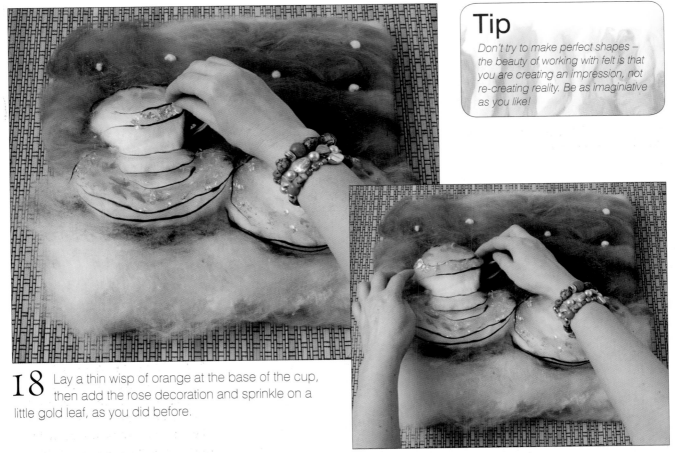

18 Lay a thin wisp of orange at the base of the cup, then add the rose decoration and sprinkle on a little gold leaf, as you did before.

19 Finish with a fine layer of orange fleece placed gently over the gold leaf.

20 Construct the cake before placing it on the picture. Cut out the shape of the case from turquoise fleece. Then take a piece of carded pink fleece and tease it out so that the fibres are all lying in the same direction.

21 With your fingers, mix in a little Mulberry silk in pink and white. Fold in the edges of the fleece to make the top of the cupcake.

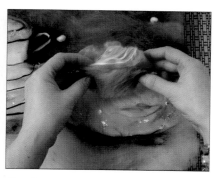

22 Tuck the top of the cupcake behind the case and place the cake on the picture.

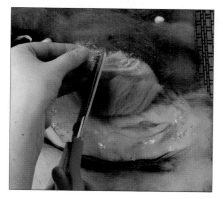

23 Trim off tiny pieces of yellow Angelina and sprinkle these on top of the cake.

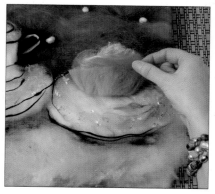

24 Add some shading to the top of the cake in the form of thin wisps of dark pink fleece, mainly on the right. Wrap the wisps around the back of the cake to retain the shape.

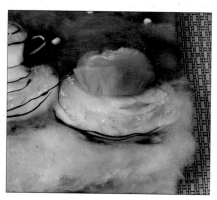

25 Similarly, lay some fine wisps of dark blue fleece on the right-hand side of the cake case. Take two tiny pieces of red fleece – one light and one dark – and roll them together to form the cherry. Place it on the picture, tucked gently under the top of the cake.

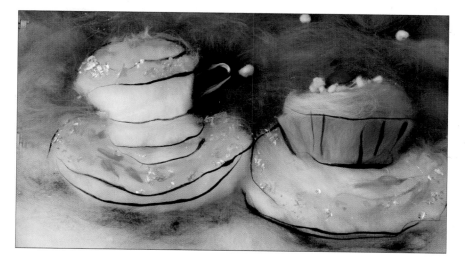

26 Lay some pale strips of light yellow fleece around the bottom of the cake, mainly on the left, then sprinkle small pieces of white wool nepps on top of the cake to resemble sugar. Finally, define the cake case using small slivers of black.

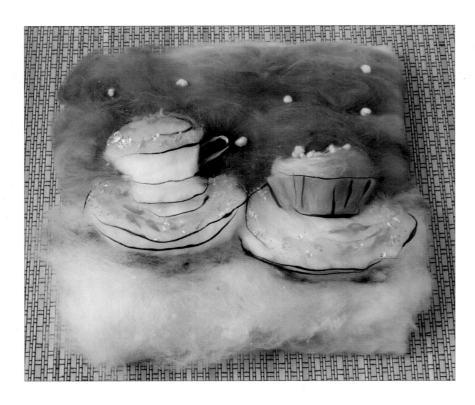

27 Your picture is now ready for felting. Felt the picture following the instructions on pages 42–44.

Refining the detail using needle felting

28 Use needle felting to re-attach any of the white dots that have come loose during the felting process.

29 Give the cherry a more rounded shape and redefine the shape of the cake. Use the needle to pull up the cake case and reshape it, giving it a more wavy edge.

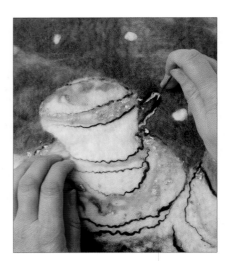

30 Finally, tidy up the lines around the cup, saucer and plate and reshape the handle on the cup. When you are happy with your picture, you can start stitching.

Machine stitching

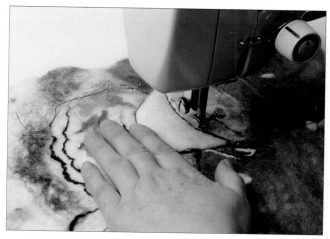

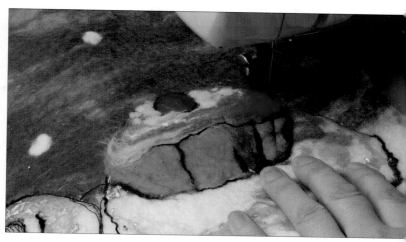

31 Outline the cup using black thread on the top of the sewing machine and in the bobbin. Snip off the threads, then outline the saucer in the same way. Continue to stitch around all the black lines on the saucer, plate and cup. When you have finished, snip all the threads.

32 Outline the cake, then stitch along the creases on the cake case to sharpen them.

Tip
Remember to attach an iron-on adhesive backing before you start stitching, as described on page 46.

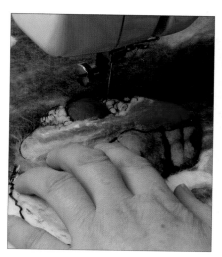

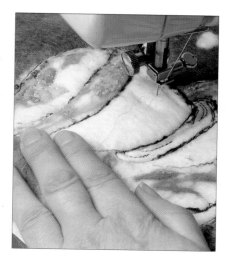

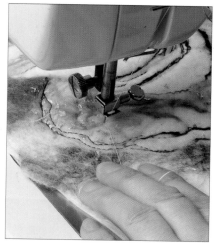

33 Stitch randomly over the top of the cake to give the impression of sugar and icing piled unevenly on the top and, finally, outline the cherry.

34 Rethread the machine with cream thread on the top and in the bobbin and lay lines of stitching down the side of the cup to introduce surface texture. Also lay some stitching along the handle of the cup.

35 Define the shape of the rose motif by adding some stitching in a spiralling motion.

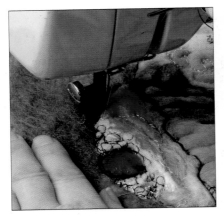

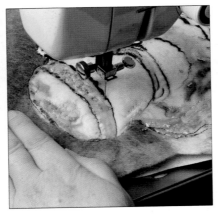

Tip

Remember that the stitching doesn't need to be too neat – in fact, uneven, wobbly lines are better suited to this style of work.

36 Stitch over the top of the cake to further enhance its texture.

37 Replace the thread on the machine and in the bobbin with a gold metallic thread and stitch over the gold band on the cup in a swirling pattern.

124

38 Edge the black lines around the cup, plate and saucer in gold, and add the swirling gold patterning around the edges of the plate and saucer.

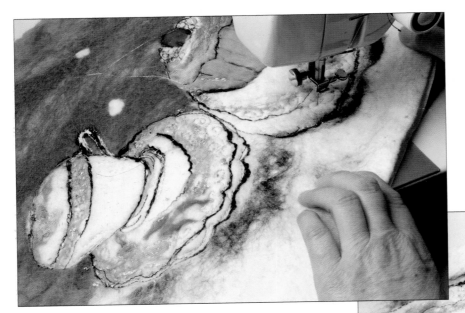

39 Rethread the machine with light green thread on the top and in the bobbin and lay some green stitching over the leaves on the saucer and inside the cup.

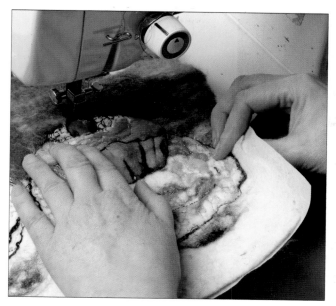

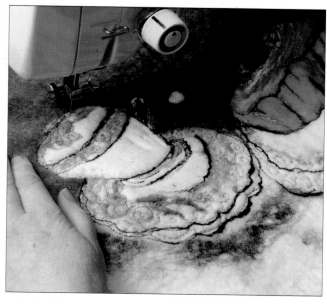

40 Change to a deep pink thread on the top of the machine and in the bobbin and stitch a highlight on the top of the cherry. Add some pink stitching to the top of the cake.

41 Use the same thread to further define the roses on the plate, saucer and cup.

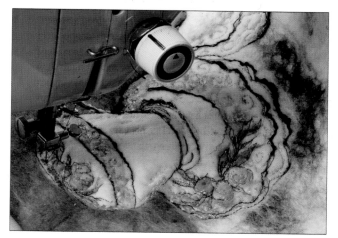

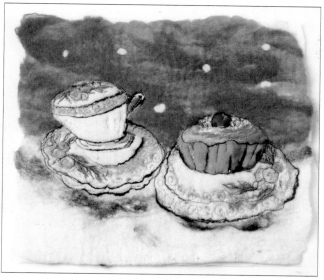

42 Now, with dark green thread on the top of the machine and in the bobbin, define the outlines and veins of the leaves. Take the green stitching around the roses to help them stand out.

43 When you are happy with the machine stitching, make sure all the cross threads are cut off. You are now ready to start hand stitching.

Tip

Be creative with your stitching – you don't need to follow my design exactly. Lay on the colour as if you were adding the finishing touches to a painting.

Hand stitching

For all the hand stitching I use a doubled six-stranded cotton.

44 Go over some of the black edges using simple running stitches worked in white thread. Also use white thread to add some long, vertical highlights to the edge and side of the cup. Create a raised effect on the gold patterning around the plate and saucer by covering it in random raised dots, made by overlaying four or five stitches on top of each other using gold-coloured metallic thread.

45 Work a similar design over the gold patterning around the rim of the cup.

46 With turquoise thread, create highlights on the cake case using single straight stitches, as you did on the cup. For the hundreds and thousands on the top of the cake, stitch raised dots in a range of bright colours, including yellow, orange, turquoise and deep pink.

Finishing

Finish your picture following the guidance on page 51.

INDEX

anemones 4, 92, 100–109
Angelina 4, 14, 27

bamboo tops 14
berries 78, 80–91
birds 6–7, 76–91
blossom 6–7, 76–77, 80, 83
buildings 27, 29, 54, 55, 61, 63, 68–72

cakes 110, 112–127
carding 12, 13, 15, 16, 30, 31–35, 64
colour 6, 9, 15, 20, 22–25, 29, 49, 54, 55,
 59, 63, 64, 82, 92, 100
 blending 16, 26, 30, 31–35, 64
 of merino 11, 13, 22, 30, 34, 36, 37, 64,
 82, 100, 116
composition 28–29, 94
contrast 4, 6, 23, 27, 41, 48, 58, 98,
 100, 113
crockery 113–127

fences 12, 29, 49–50, 71
fields 12, 28, 50, 52, 61, 65–75
finishing 51, 75, 91, 108, 127
fleece 12, 15, 18
 rainbow fleece 12, 100, 102
flowers 15, 39, 46, 49, 92–109, 115
fruit 110, 111

glitter 15, 27, 34, 55
gold leaf 14, 15, 27, 116, 119, 120

hills 16, 20, 23, 29, 38, 52, 61, 94

inspiration 20–21

landscapes 6, 14, 20, 29, 52–75,
 94, 110
 patchwork 24, 62, 64–75
layering (fibres) 36–41, 64–69, 82–85,
 100–105, 116–122
linen noil 16

merino 11, 12, 13, 14, 15, 20, 22, 26, 28,
 29, 30, 36, 52
 merino tops 11, 12, 30, 34, 64
 merino rovings 15
moon 29, 40, 41, 45, 94

needle felting 69–70, 76, 86–88,
 106, 122
 equipment 18
 felting needles 18, 27, 45, 111
 techniques 30, 45

perspective (depth, distance) 23, 24, 27,
 28, 31, 49, 54, 83, 94, 96
poppies 67, 72, 74, 94, 98–99
projects
 anemones 100–109
 bird with berries 82–91
 patchwork landscape 64–75
 tea and cake 116–127

rovings 15 see also merino

sheep 4, 12, 20, 39, 40, 45, 47, 50,
 52, 110
shoes 110, 111
silks 14, 15, 34, 94
 Mulberry silk 15, 16, 34, 37, 38, 64, 69
 silk noil 14, 15, 16, 37, 39, 40, 94

silk tops 15
 tussah silk 12, 15, 76
skies 4, 14, 20, 23, 25, 27, 28, 29, 52,
 55, 56, 58, 60, 61, 64–65, 68, 94
snow scenes 12, 14, 25, 60
still life 20, 110–127
stitching 26, 30, 46, 64
 equipment 19
 hand stitching 8, 24, 30, 49–50, 62,
 73–74, 90, 108, 126
 machine stitching 8, 19, 23, 24, 27, 30,
 46–48, 55, 62, 71–73, 76, 80, 89–90,
 107–108, 111, 113, 123–125

texture 6, 13, 14, 15, 16, 26–27, 31, 40,
 41, 64, 67, 68, 72, 76, 117, 123, 124
threads 12, 19, 27, 29, 30, 34, 46, 48,
 49, 54, 55, 78, 113
trees 4, 16, 20, 29, 39, 46, 50, 52, 61, 66,
 67, 69, 71, 73

waters 4, 52, 54, 55, 56
wet felting
 equipment 10–11, 16–18
 techniques 30, 42–44
wool nepps 15, 64, 67, 72, 98
wool tops 12, 13, 31, 36, 37
 see also merino

128

Glenkinnon Ram

46 x 46cm (18 x 18in)

*The ram's head was worked from a photograph I had
taken. The ram actually had a white coat, but as I
had been kindly given some beautiful brown, curly
fleece I decided to combine the two. I love the result,
although I am not sure such a creature actually exists.*